CW00822440

WIDNES
AT WORK

PEOPLE AND INDUSTRIES THROUGH THE YEARS

JEAN & JOHN BRADBURN

AMBERLEY

First published 2017

Amberley Publishing
The Hill, Stroud
Gloucestershire, GL5 4EP

www.amberley-books.com

Copyright © Jean & John Bradburn, 2017

The right of Jean & John Bradburn to be identified as
the Authors of this work has been asserted in accordance
with the Copyright, Designs and Patents Act 1988.

ISBN 978 1 4456 7218 2 (print)
ISBN 978 1 4456 7219 9 (ebook)

British Library Cataloguing in Publication Data.
A catalogue record for this book is available
from the British Library.

Origination by Amberley Publishing.
Printed in the UK.

CONTENTS

ACKNOWLEDGEMENTS

My thanks to Bob Martindale for once again giving his time and for access to his wonderful photo collection. To Billy Hyland of Aaron Photo-Archive for supplying his wonderful photographs of life at 'The Crispy' and Laporte.

To Jean Morris; her books bring Widnes to life and she has inspired me to write my own local history books.

I must also thank everyone who contributed to the oral histories in the Halton Heritage Partnership Working Lives project. You can hear them all at: www.haltonheritage.co.uk/halton-heritage-partnership.

THE EARLY YEARS

The development of Widnes from an agricultural backwater to the important chemical centre it became was due to the men and women who came to the town and made it their own.

Although sitting in a strategic position on the River Mersey, Widnes does not appear in the Domesday Book. The Saxton's map of Lancashire 1577 shows only the settlements of Farnworth, Appleton and Ditton.

Widnes was only a district name within the West Derby Hundred. Originally known as Vidnes, it later appears as Wydnes and Wydness. It has been suggested the name originates from the Danish – 'wide nose'. Others suggest it refers to trees and the district of Woodend would support this, the area being densely wooded in the early years; there was even a man appointed Forester of Widnes. What is certain, however, is that the important villages in the early years were Farnworth and Appleton. Although Farnworth was the most important village, having its own church and court, the main administrative centre was Halton Castle across the Mersey. A reliable means of crossing the river was needed and the first ferry from Runcorn to Widnes was established around 1178 by the 6th Baron John FitzRichard.

Around 1180 a chapel was built in Farnworth, which was dedicated to St Wilfrid. At that time the village was known as St Wilfrids-on-the-Hill. It was a chapel of ease to the mother church at Prescot. By 1360 a fine stone tower had been added to the chapel and would dominate the area looking across from Halton Castle.

In 1350 Henry Duke of Lancaster (12th Baron of Halton) proclaimed that the peasants would be free. This meant that the freemen of the area could cut turf and graze their cattle. Although they could now own the land in their own right, they still had to pay a fee of 1 shilling per acre. The status of Farnworth was further enhanced in 1507 when Bishop Smythe endowed £350 to establish a grammar school.

This was a remote area and perhaps the only visitors would be pilgrims passing through Farnworth on the way to the ferry at Runcorn Gap. The area was agricultural and the landscape was fields, marsh and windmills. The workers' homes would be foul-smelling cruck cottages shared with their animals.

Cottage industries were starting to appear and the first was the making of clocks and watches. Watches were first produced in the eighteenth century and some believe it was introduced to the area by a Huguenot refugee. The first recorded will of a watchmaker

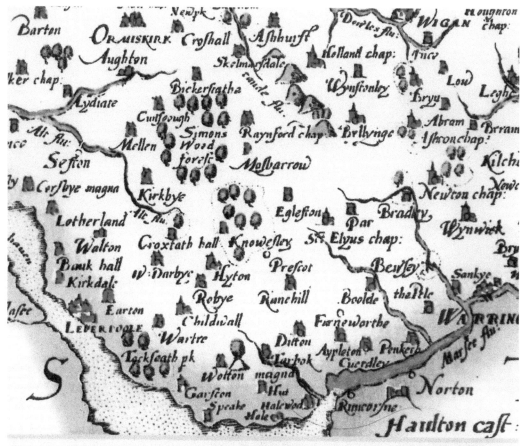

SAXTON'S MAP OF LANCASHIRE 1577

Lancashire in 1577.

in the district was in 1765. The invention of the lever escapement by Thomas Mudge in London at about this time was a great improvement to pocket watches. Prescot and the villages around became a centre for the industry. The work required great skill and precision but this affected their eyesight and, sadly, when it started to fail they found themselves out of work. Baines Directory of 1825 shows James Abbott, Wm Doward and James Hunt manufacturing watches in Farnworth as well as a watch movement and toolmakers in Appleton. They were skilled craftsmen, working in their own home, but they were outworkers for the master watchmakers of Prescot and were often paid in provisions or watches – a very unfair system.

Farnworth also had a flourishing sail cloth industry. It was originally produced in the home. The work was gruelling and the workers were paid on a piece-work system. The work involved whole families – men, women and children working together. By 1825 there was a marked transition to factory production. At this time there were five factories: William Norland, Thomas Shaw, Thomas Smythe, Thomas & William Kidd and Longton & Leather. The Kidd family had worked making sail cloth since the eighteenth century. The map of Farnworth shows the factories and warehouses in the village.

Watchmaker.

As early as 1791 there was a small factory in Appleton to draw pinion wire. From the late 1800s it was owned by Francis Heyes. He ran the wire works, which were situated near the park, through the late 1800s and after he died in 1902 his wife took over the business.

Appleton remained a pleasant rural village – a far cry from the pollution and working conditions of Widnes. There were the typical occupations, blacksmith, wheelwright, tailor and shoemaker. Appleton Quarry on Deacon Road provided employment and produced the beautiful red sandstone that we can still see in the village today. The owner, James Randle, lived in Fairfield house.

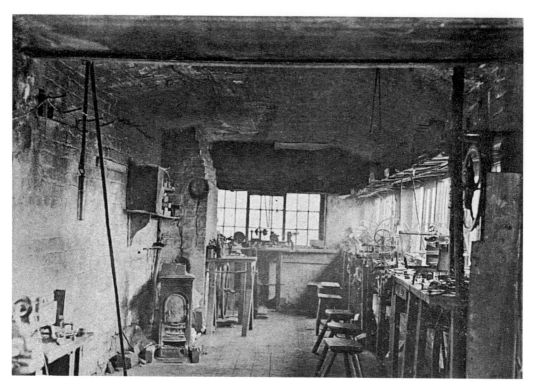

Watch factory.

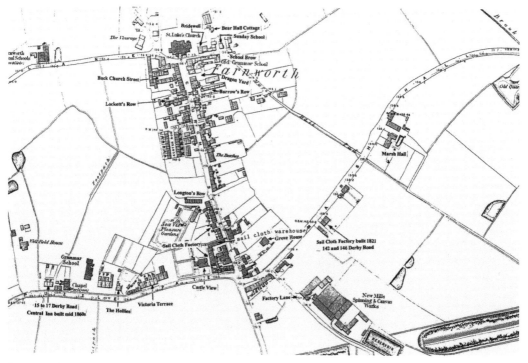

Farnworth in 1875.

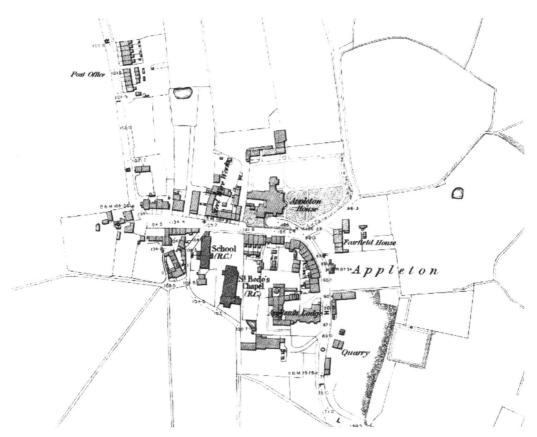

Appleton in 1875.

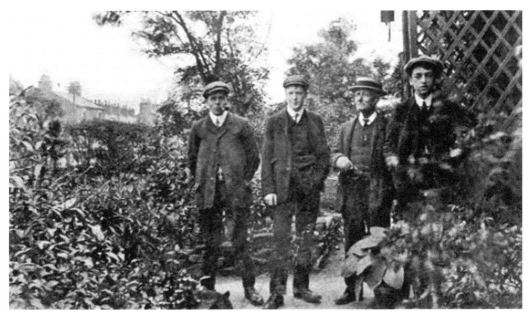

Francis Heyes with his colleagues F. Woolley, W. Woolley and J. Whitfield in Appleton village.

Appleton Quarry.

EARLY TRANSPORT LINKS

The strategic position of Widnes on the River Mersey by the Runcorn Gap would eventually shape the town's history. In the early years, despite the ferries, Widnes remained an isolated area, relatively untouched by industry, although it was becoming popular with day trippers visiting the river.

The first hint of change to Widnes was in 1755 when Henry Berry, an engineer from Liverpool docks, planned the Sankey Brook Navigation. The Sankey Brook was a small river running into the Mersey. The Act authorising the Sankey Brook Navigation from St Helens was passed that year and by 1757 was carrying coal. The salt works of Cheshire desperately needed coal for fuel, most of which came across the Mersey from Lancashire and then up the River Weaver. On the Lancashire side of the Mersey there was no such navigable route and goods were still being carried on old roads, dirt tracks or the newer turnpikes. There was also a need to bring coal down to the new growing chemical industries of Liverpool. The Sankey can thus be credited with the industrial growth of the region.

Built primarily to take coal from Haydock and Parr down to the Mersey and on to Liverpool and the salt fields of Cheshire, the final traffic on the Sankey Canal was very different, and in the opposite direction, consisting of raw sugar from Liverpool to the sugar works at Earlestown, Newton-le-Willows.

Henry Berry worked with William Taylor to survey the canal, for which they charged £66. Berry had previously worked with Thomas Steers, Liverpool's First Dock Engineer. He was Liverpool's Second Dock Engineer, but was appointed engineer for the navigation when those promoting it convinced the Dock Trustees that they should release him for two days a week. It is not known whether it was Berry or the promoters who presented the plans to Parliament as an upgrade to existing river navigation, despite the fact that it would be built as a proper canal, but it is thought to be the only time that a canal was authorised by Parliament without anyone petitioning against it. This is possibly the reason why the work of Henry Berry is not recognised in the same way as the Duke of Bridgewater.

The canal's immediate commercial success was followed soon after by the Bridgewater Canal. This led to a passion for canal building, and for further extension schemes to be proposed for the Sankey Canal, although Francis Giles' proposal to link the canal to the Bridgwater Canal was not implemented, and neither was a plan to link the canal to the Leeds and Liverpool Canal near Leigh.

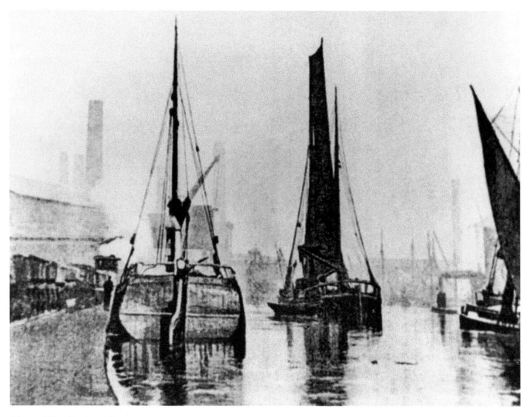

Above: The Sankey Canal.

Below: Gaskell Deacon and Hutchinson No.1 workers crossing the canal.

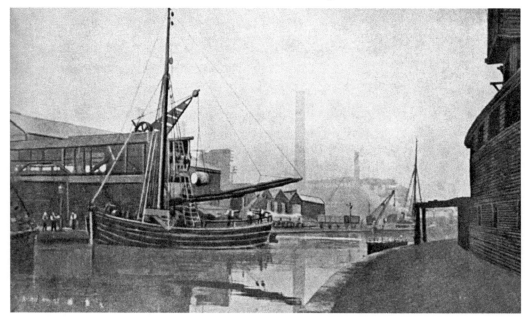

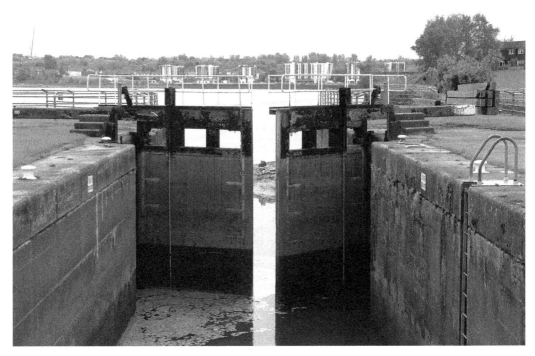

Widnes lock gates.

The Sankey was built for Mersey flats, the sailing craft of the local rivers – the Mersey, Irwell and the Weaver. To allow for the masts of the flats, all the roads in the canal's path had to be carried over on swing bridges. The canal was extended to Fiddlers Ferry in 1762 to provide better access to the River Mersey. In 1829, plans were made to extend the canal from Fiddlers Ferry down to Woodend (Widnes). In 1832 the extension known as 'The New Cut' was built down to new locks at Widnes.

The canal, however, was soon to be in competition with the railway. An Act of Parliament for the St Helens and Runcorn Gap Railway was obtained on 29 May 1830. The original capital was £120,000, one-third of which was raised from local coal owners, salt-makers and Liverpool merchants. These included James Muspratt, soap and alkali manufacturer, and Peter Greenall, who had interests in the brewing, coal and glass manufacturing industries. Peter Greenall was elected as the first chairman of a board of ten directors. At the south end of the railway, Widnes Dock was built, which led into the Mersey. This was the world's first rail-to-ship facility. The line opened officially on 21 February 1833 but the dock was not completed until August 1833. The extension to the Sankey Canal opened on 24 July 1833. From Widnes Dock a single line crossed the extension to the canal by a swing bridge and then climbed steeply (so steeply that for a section trains had to be pulled by a stationary engine). This was the start of the huge growth in the population of Widnes as the dock employed boatmen and dock workers.

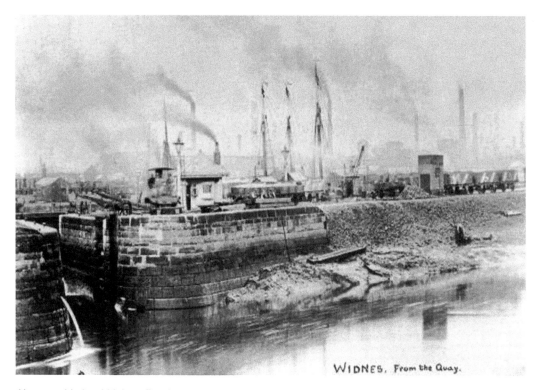

Above and below: Widnes Dock.

However, the line had cost a lot more than the company had expected and as a consequence they were unable to build branch lines to as many collieries as they had planned. Passenger usage was also lower than expected. The railway was struggling. The canal proprietors must have let out a huge sigh of relief. After just one year the railway company was almost bankrupt while the new canal went from strength to strength. The railway began a toll reduction war but the canal won this battle too and gained even more business.

The struggling shareholders voted to amalgamate with the Sankey Brook Navigation, but the canal would not agree. Talks reopened between the canal and the railway with a view to the two becoming one. It was decided that the canal should be sold to the railway and the two companies would become the St Helens Canal and Railway Company. This was a surprise as many canals were losing business to the new railway companies. However, the Sankey Brook Navigation continued to outdo its big rival. Tonnage on the canal had reached almost double that of the railway by the time the Act was obtained, allowing the two companies to join forces.

In 1868 came a major change to the Widnes landscape with the opening of the railway bridge – the first fixed crossing of the Runcorn Gap, taking the railway from Runcorn to Liverpool. The building of the bridge brought large numbers of construction workers to Widnes. In August 1866 the first girder was completed and in November a ceremony was held to celebrate the second girder. The workmen cheered gustily and were congratulated on their excellent work, although the champagne was only enjoyed by the dignitaries. When completed, the bridge allowed pedestrian access to Runcorn at a cost of one penny; handcarts, etc., were three pennies. This charge was considered harsh for lowly paid workers but the railway company refused to lower the charges.

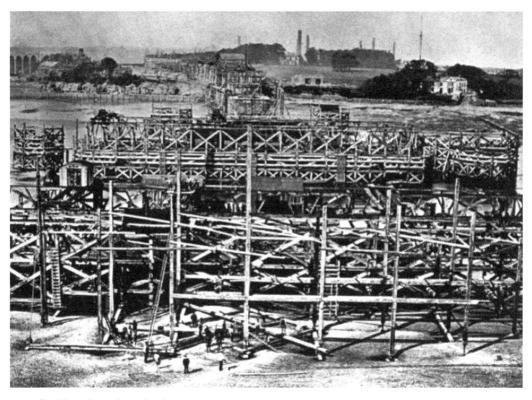

Building the railway bridge.

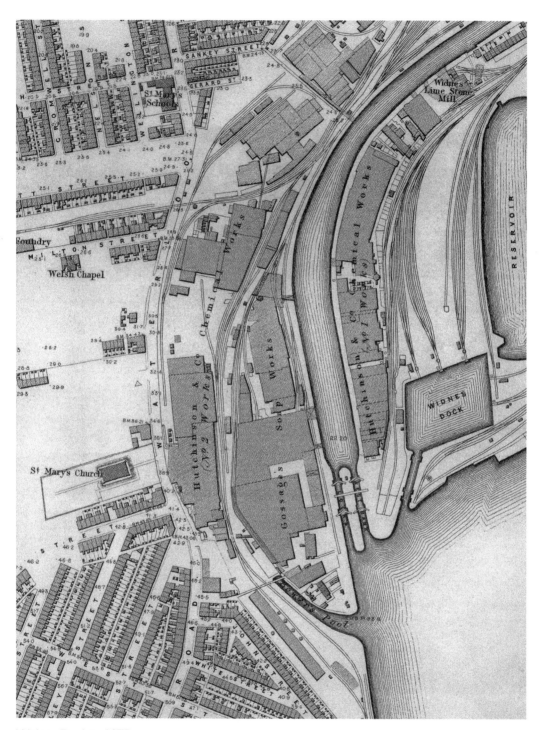

Widnes Dock in 1875.

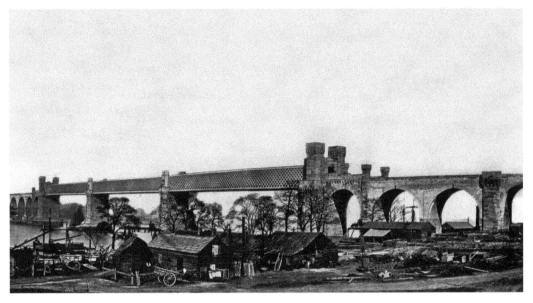

The railway bridge was the first fixed crossing of the Runcorn Gap.

THE NINETEENTH CENTURY: THE MEN WHO FOUNDED THE ALKALI INDUSTRY

The arrival of the founders of Widnes industry, including John Hutchinson and William Gossage, and the coming of the canal and the railway transformed Widnes from a sleepy backwater into a major industrial centre, changing workers' lives forever.

Although it is John Hutchinson who is said to be the founding father of the Widnes chemical industry, the story starts in Liverpool when James Muspratt opened his soda factory in 1822. By 1823 the work was producing soda by the LeBlanc process.

The story of the LeBlanc process is an interesting one. In 1775 France was finding it difficult to import natural soda. The Academy of Sciences offered a prize to anyone who came up with the solution of manufacturing alkali from salt. Nicholas LeBlanc was the winner. He was awarded his patent in 1791 and set up works in St Denis. Sadly the French Revolution disturbed his ambitions and he later found himself in the workhouse, where he committed suicide in 1806 at the age of fifty-three.

JAMES MUSPRATT (1793–1886)

Muspratt was born in Dublin in 1793. He became a midshipman in the British Navy and sought adventure in the Peninsular War with Napoleon. However, he found naval discipline not to his liking and eventually deserted. He arrived in Liverpool in 1822 after receiving a small inheritance from his father. Liverpool in the early years of the century had a number of soda works including Lutwyche and Hill, so although Muspratt's soda factory was not the first, it was the first important alkali works in Britain. He started in a small way, setting up a company – Muspratt & Abbott – in Vauxhall Road, manufacturing prussiate potash, and later went over to make soda by the LeBlanc process. The good people of Everton were not happy with the pollution coming from the Vauxhall works and nuisance bills started to be posted on the walls, and in 1838 Muspratt was taken to court. The trial at Liverpool spring assizes lasted three days. He was charged with creating and maintaining a nuisance to the annoyance and injury of the inhabitants. Witnesses spoke of dead poplars, tarnished doorknockers and even damaged broccoli. He was accused of affecting land values in the area. The jury found him guilty after deliberating for two hours. Despite this verdict, Vauxhall works continued to provide employment for about 140 men, and making 5,000 tons of black ash annually. Looking to get out of Liverpool and avoid more prosecutions, Muspratt opened works at Newton near St Helens, although he continued to live in a large mansion in Seaforth. Here he entertained actors, poets and writers including Charles Dickens. It was his son, Frederick, who opened a factory in Wood End by the canal in 1852, manufacturing alkali by the LeBlanc process. The Muspratt family continued to contribute to Britain's chemical industry for many future years.

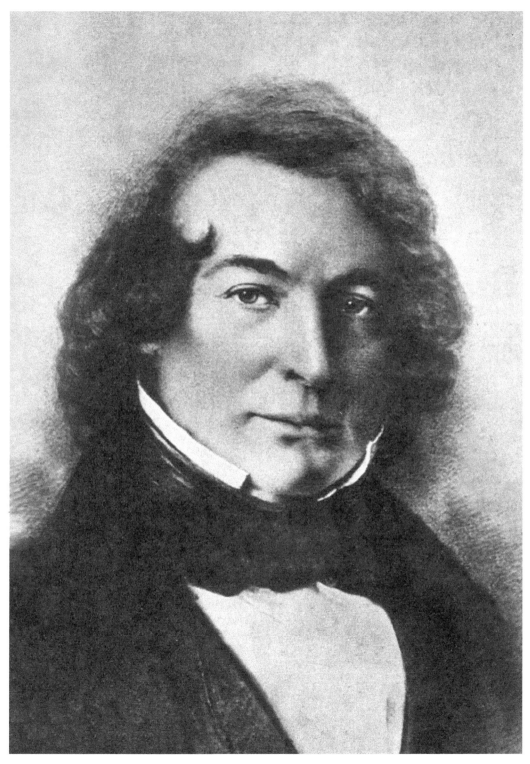

James Muspratt.

Muspratt Works.

JOHN HUTCHINSON (1825-65)

John Hutchinson was a protégé of Andrew Kurtz. They met through a friendship with Kurtz's son, a fellow chemistry student in Paris. Kurtz had been involved in a costly lawsuit relating to his solitary patent on sulphuric acid furnaces. John was offered a post as manager at the Kurtz alkali works in St Helens. When Kurtz died the company passed to his son, Andrew George Kurtz, but Hutchinson did not stay long: at the age of only twenty-two he was preparing to become an alkali manufacturer on his own account. In 1848 he applied for a lease of land from the St Helens Canal and Railway Company. By 1849 he had established his No. 1 factory at Spike Island. He had quickly appreciated that increased freight charges would be a problem for St Helens and recognised that Widnes was a better base for his alkali works. With his business thriving he needed more land and managed to persuade the government to sell him the land on Widnes Marsh. By 1851 he was employing 100 men. He was a good employer and well regarded: while the work was hard, his workers were one of the first to enjoy a works canteen. His No. 2 factory was built in 1859. He could truly be credited as bringing the first significant chemical manufacturing to Widnes. His partner at this time – Oswald Earle – operated a small lime works on the banks of the canal.

In 1850 Hutchinson strengthened his ties with Widnes by marrying Mary Elizabeth Kinsey and settling down in Appleton Lodge; together they had five children, two boys and three girls.

Above and below: Widnes Dock in 1875.

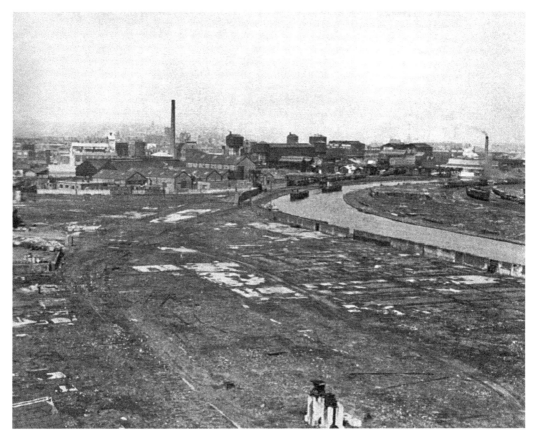

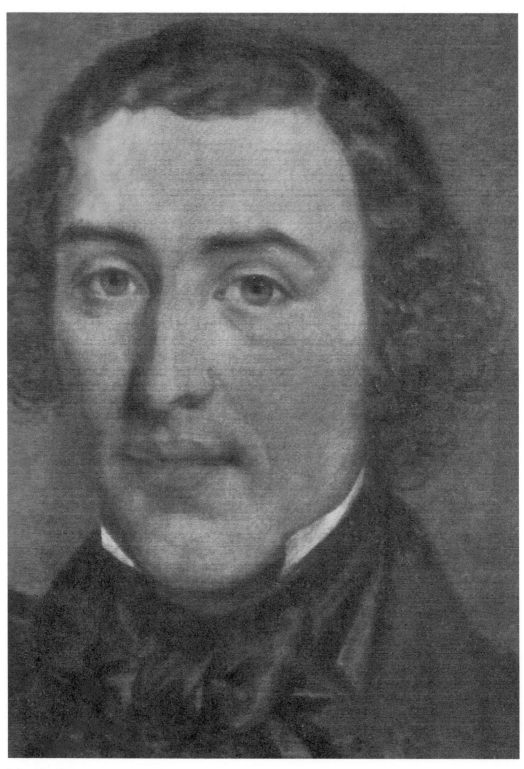

John Hutchinson.

Appleton Lodge, the home of John Hutchinson.

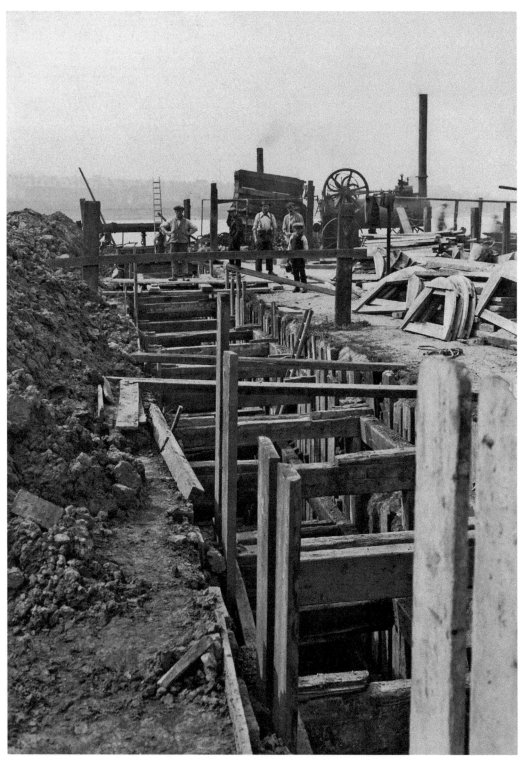

Construction Sewerage Works, West Bank.

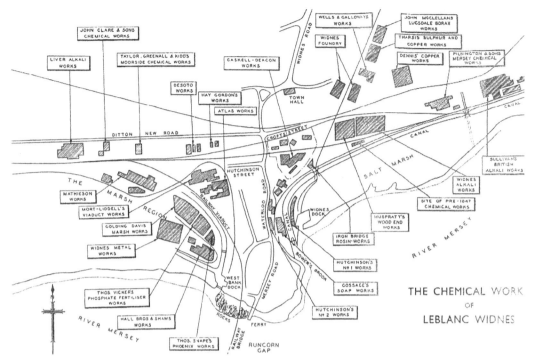

Above: Leblanc Works.

Below: Black Ash revolver Leblanc process.

In 1856 he established the Widnes Gas and Water Co. He was allowed by Act of Parliament to supply water and gas to the town. When the first gas lights appeared in Widnes it was Hutchinson's company who supplied the gas. However, his water supply came under constant criticism. The water supply came from a well on Spike Island; it was often contaminated and concern grew from the Local Board of Health. They were able to acquire the company in 1867 and decided to establish a reservoir at Pex Hill, which opened in July 1869. The waterworks were officially opened by John McLellan, Chairman of the Local Board. A cholera scare in 1866 and the vast increase in population influenced this important decision. A new sewerage system was also built in West Bank.

However, despite this setback, as the chemical industry grew so too did many other supporting industries in the town. Hutchinson died at the young age of forty in 1865 from consumption. When he died he employed 600 men and owned extensive land in Widnes. He was buried close to St Bede's church.

WILLIAM GOSSAGE (1799–1877)

William Gossage opened his works on the opposite bank of the canal in 1850. He was from Burgh-in the-Marsh in Lincolnshire and had chemical works in the Midlands.

Gossage took out his first patent at the age of twenty-four: a portable alarm for clocks and watches. He first set up business as a druggist in Leamington making 'Leamington Salts'.

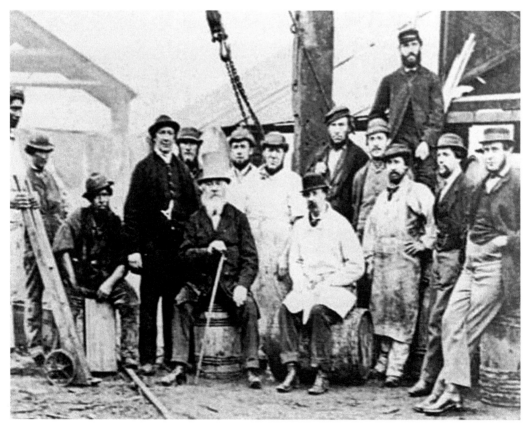

William Gossage with his son Frederick and soap workers in 1861.

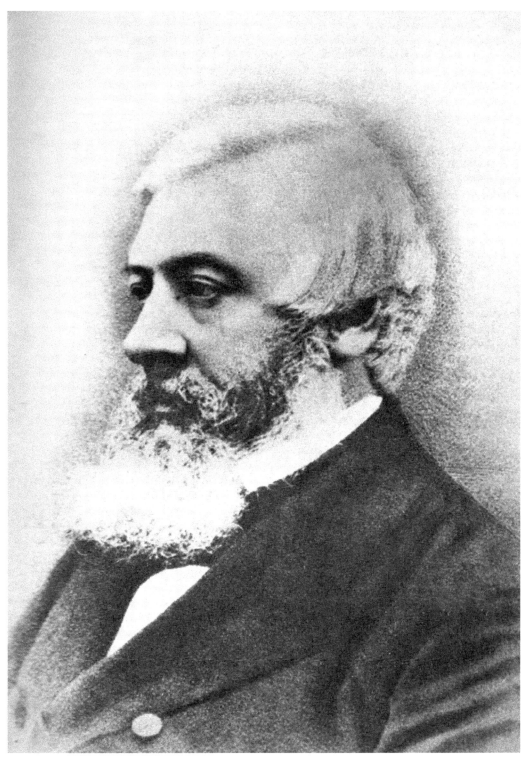

William Gossage in 1861.

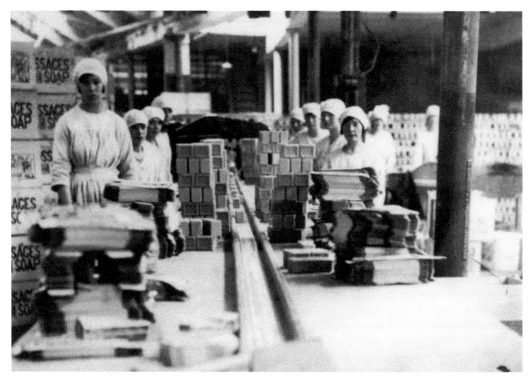

The new packaging department and soap workers at Gossage's factory.

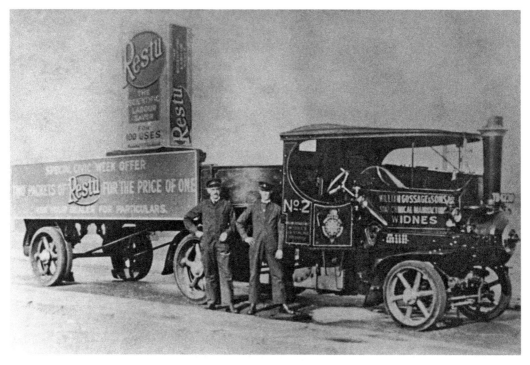

Gossages steam wagon advertising Restu Soap ('washes white overnight').

FOR GREASY POTS & PANS

Gossages' Dry Soap

Gossage's advert.

He then formed British Alkali Works in Stoke Prior, Worcestershire. Local opposition to pollution led him to move to Birmingham, where he manufactured white lead. He arrived in Widnes in 1850, where he set up opposite Hutchinson's No. 1 factory. His relationship with Hutchinson did not end well. When his plan to take alkali waste from local manufacturers to produce sulphur did not succeed, Hutchinson refused to release Gossage from his contract. This was an example of Hutchinson's hard business practices.

Gossage's Widnes chemical company was at first manufacturing alkali on a small scale, but after 1855 he was a successful soap manufacturer. The duty on soap was removed in 1852 and this may have been the stimulus for him. His original patent for silicated soap was Patent BP 762/54, patented on 3 April 1854; this white- and blue-mottled soap was known as the 'World Famous Magical Soap'.

Gossage had developed a new process which made soap affordable to the poorest workers.

He died in 1877, having left the polluted Widnes air for the leafy delights of Bowdon, near Altrincham. During his long career he took out over fifty patents relating to every branch of heavy industry.

JOHN MCCLELLAN (1810–81)

Another chemical pioneer was John McClellan, although not a lot is known of his industrial activities. He was born in Liverpool in 1810 and arrived in Widnes in 1847, at about the same time as John Hutchinson. He started to manufacture Borax and tartar salts at his

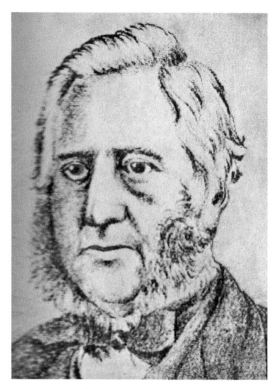

Left: John McClellan.

Below: Highfield House Home of John McClellan.

North British Chemical Company in the Lugsdale area. It is believed that the soda he needed was purchased from Hutchinson's works. He lived at Highfield House and became involved in civic life, being a member of the Widnes Local Board. McClellan married Mary Gaskell, the daughter of a Liverpool cotton broker, in 1844. They had five children: one son (Alexander, who later joined his father in the business) and four daughters. Sarah Jane, their eldest daughter, married Henry Brunner, John Hutchinson's chief chemist. Sadly McClellan's business became bankrupt in 1879 and he died in Appleton in 1881. His estate was valued at £81.

HENRY DEACON (1822-76)

Henry Deacon was born in London in 1822. His family belonged to an unusual religious movement – the Sandemanians. It was this family connection that led a young Henry to meet Michael Faraday and witness some of his experiments at the Royal Institution. This contact with such an outstanding scientist certainly influenced Deacon's future career as a successful chemical manufacturer. He was first apprenticed to a Galloway's engineering works but later moved north to the Naysmyth and Gaskell's works in Patricroft, beside the Bridgewater Canal. It was here that the steam hammer was invented (Henry actually helped James Naysmyth to patent his invention). He had now worked with Faraday and Naysmyth, who were both distinguished in their field. He easily obtained a post at Pilkington's in St Helens, where he must have impressed John Hutchinson because when Hutchinson moved to Widnes he offered Henry the post of works manager. There was, however, a clash of personalities as Deacon was not impressed with the processes of No. 1 Works. He was keen to improve and experiment; indeed he continued to write patent applications. In 1853 Deacon left Hutchinson and went into partnership with the younger of the Pilkington brothers, William, to establish their own alkali works in Widnes, on land between the Sankey Canal and the St Helens and Runcorn Gap Railway. This partnership was dissolved in 1855. In a new partnership with his previous employer, Holbrook Gaskell, who provided the capital, the firm of Gaskell, Deacon and Co. was founded. Between 1854 and 1876 Deacon, alone or in collaboration with others, filed at least twenty-nine patents, all relating to alkali manufacture. Deacon also presented a number of papers to learned societies, including the British Association for the Advancement of Science in 1870, the Chemical Society in 1870 and the Warrington Literary and Philosophical Society in 1874.

FERDINAND HURTER (1844-98)

In 1867 Henry Deacon took on a chemist, Ferdinand Hurter, on a month's probation. Hurter was born in Switzerland and became the chief chemist to the company. He founded the Central Laboratory and became a leading authority on the alkali industry.

HOLBROOK GASKELL (1813-1909)

Holbrook Gaskell was born in Liverpool in 1813. In 1836 he formed a partnership with James Nasmyth, which led to the creation of Nasmyth, Gaskell and Company, and the building of the Bridgewater Foundry at Patricroft near Manchester. Ill health brought an end to his work at Bridgewater Foundry. In 1855 Gaskell was well enough to enter into a second partnership with the industrial chemist Henry Deacon, who had worked with him

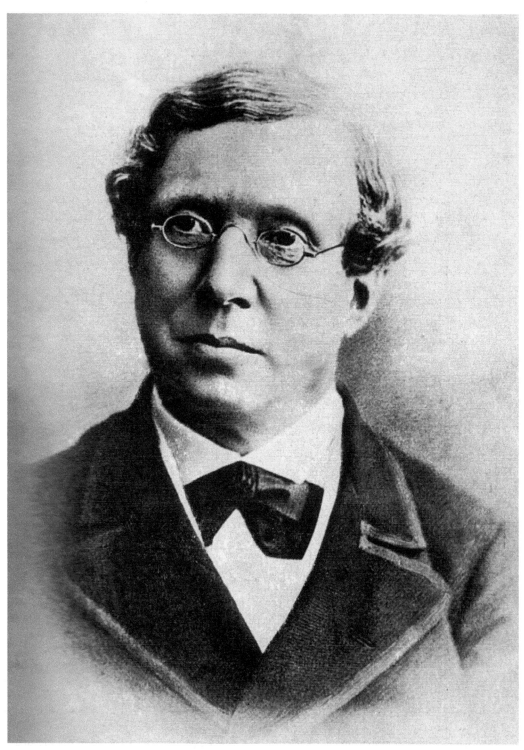

Henry Deacon.

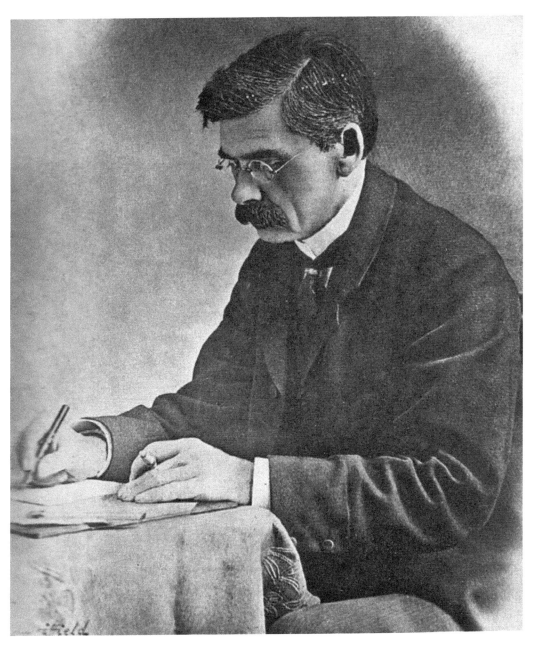

Ferdinand Hurter.

in Nasmyth, Gaskell & Co. He first financed Henry Deacon's ammonia–soda experiments at Widnes. When they saw no immediate future for this process, they established one of the largest and most successful Leblanc factories in Widnes. In 1860, when the governments of Britain and France formed a treaty to raise duties on materials made from salt, Gaskell went with Edmund Knowles Muspratt to Paris to negotiate terms for the manufacturers. Gaskell remained a director of the company until 1890, when it became part of the United Alkali Company. He became vice-president and later president of that company.

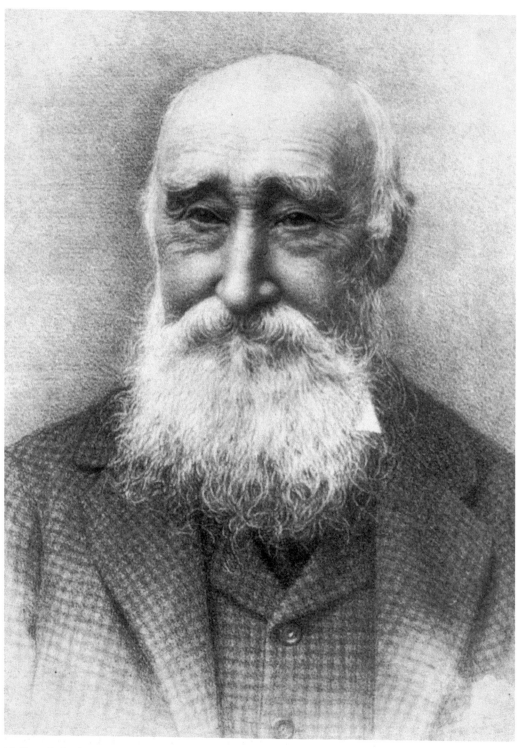

Holbrook Gaskell.

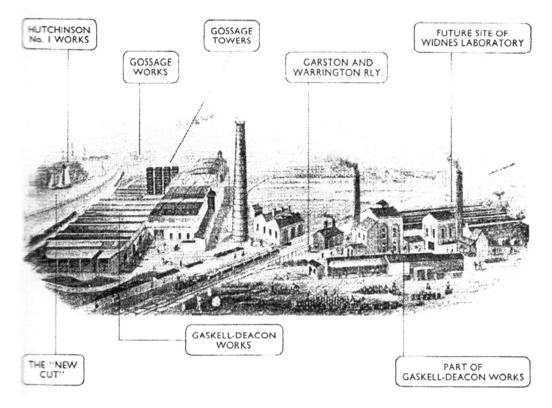

HUTCHINSON No. I WORKS

GOSSAGE TOWERS

FUTURE SITE OF WIDNES LABORATORY

GOSSAGE WORKS

GARSTON AND WARRINGTON RLY.

GASKELL-DEACON WORKS

THE "NEW CUT"

PART OF GASKELL-DEACON WORKS

Gaskell Deacon Works in 1839.

LUDWIG MOND (1839-1909) AND JOHN BRUNNER (1842- 1919)

Mond and Brunner met while working for John Hutchinson in Widnes, and together they were responsible for replacing the Leblanc process with the Solvay process.

Ludwig Mond was born in 1839 in Prussia. He received his training at Cassel Polytechnic and later worked at a laboratory in Heidelberg. He then worked at numerous German companies where he first came familiar with the Leblanc process. In the summer of 1862 he told his parents of his plan to try to earn his fortune in England. He sailed from Rotterdam and after visiting the Exhibition at Crystal Palace he made his way to Manchester. He was not successful in seeking an opportunity in the city and moved on to Widnes. Here he found a friend in John Brunner, who could speak a little German and had come to work with his brother Henry at Hutchinson's in 1861.

Mond first lived at The Mersey Inn but wrote home saying he was isolated and lonely. He was not an employee of John Hutchinson but he was allowed to experiment in the works and impressed those who met him.

In January 1863 he moved to the pleasant village of Appleton, away from the chemical pollution. He took rooms at the post office and started to make friends and finally feel at home. Appleton was the home of Henry Brunner at Cliff House, Muspratt at Bryn Felin and,

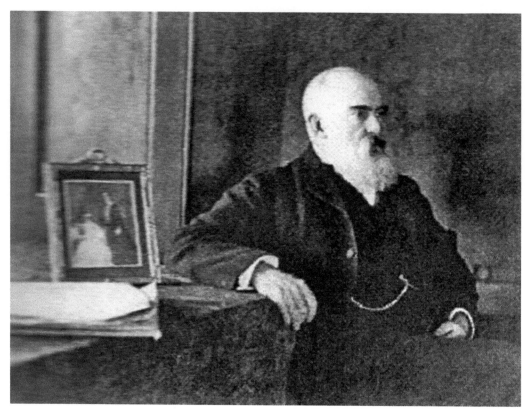

John Brunner.

of course, Henry Deacon at Appleton House. Mond's English was improving and at last he had an active social life in the town.

He was, however, becoming disillusioned with Hutchinson, who was not taking his research seriously, and Ludwig now confided his ideas only with John Brunner. He wrote to his parents and his wife-to-be, Frida Lowenthal, to say he planned to return to the continent.

He spent a month at the Smits & de Wolf factory in Utrecht but again returned to Widnes hoping to confirm a contract with Hutchinson. Relations were once again deteriorating as Hutchinson resented Mond visiting Newcastle and the possibility of him working with competitors. Mond was now back in Utrecht and the contract was never agreed as Hutchinson unfortunately died in March 1865. In 1866, John Brunner wrote to Ludwig to keep him in touch with the news from Widnes. Things were going well and he was looking forward to Ludwig returning to Widnes.

Mond finished the plant for the Utrecht firm, married Frida and returned to Widnes to make it his home. In August 1867 the couple moved into The Hollies on Derby Road. The winter of 1867 was a time of depression and many of the workers were suffering a three-day week. Mond was still optimistic; Muspratt was installing his sulphur process and a company in Glasgow had it in operation.

In October 1868 the family rejoiced in the birth of Alfred Mond (the future Lord Melchett of ICI fame). By 1871 Ludwig was referring to new developments in the soda industry – Solvay's new ammonia–soda plant. He was determined to set up a plant with his good friend John Brunner and, as we now know, they decided on a site in the Cheshire salt field at Winnington Hall.

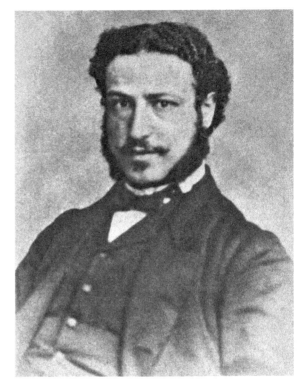

Right: Ludvig Mond.

Below: The Hollies home of Ludvig Mond.

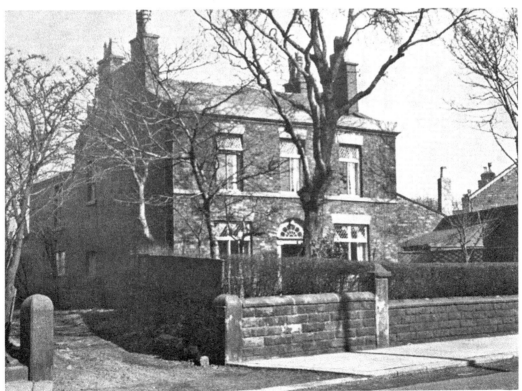

THE WORKFORCE

The success of the chemical factories in Widnes brought work to the town and resulted in a massive population increase. Census figures show that in 1801 there were 1,063 inhabitants – by 1891 this had increased to 30,011. The Irish had been arriving in the area from the early part of the century, but only for seasonal agricultural work. They found work as labourers, dockers and navvies cutting the railways and the canals. What they lacked in skills they made up for in physical strength and hard work. They would have been happy to hear that there was work in the chemical industry in Widnes but would never have dreamed how hard and dangerous that work would be. They left their home to find a better life for their families but instead faced prejudice and hostility, largely because they undercut the local labour force, but also due to the Irish political situation.

In the early days of the chemical industry, houses were rapidly built near the factories at Spike Island. These were humble dwellings lacking space and sanitary conditions. Not surprisingly, they were a breeding ground for disease. Smallpox, typhus and cholera outbreaks were common. The factory worker's house was small – two-up and two-down, with an outer yard and a shared midden. The Irish arrivals would have wondered if they may have been better off at home.

By 1871 the Newtown area was heavily Irish and their religious needs were provided by the building of St Marie in Lugsdale Road. There was also a significant Welsh community in Widnes and there were three Welsh chapels in the town.

In the 1870s an agricultural depression in Lithuania and Poland brought mass emigration. These countries had been annexed by Russia and when the emigrants arrived in Widnes they were known as Russian Poles. Like the Irish before them, they probably hoped to go to America but on arriving in Liverpool, for whatever reason, they stayed. Some had previously settled in Scotland and then made their way down to Widnes, perhaps again considering crossing the Atlantic to America. They were not made welcome but eventually became solid members of the community, many settling in West Bank.

It would be hard to exaggerate the harshness of the working conditions in the alkali factories. The hours were long, often twelve hours a day from 7 a.m. to 7 p.m. Although the work was steady, the pay was poor and families lived from hand to mouth. Visits to the pawn shop were a regular way of life and the threat of the workhouse was never far away.

The harshest department was the bleaching section. Men had to enter the Weldon chamber, which had been filled with chlorine for four days, and shovel out the powder while it was

still mixed with gas. No protective clothing was supplied so the men made their own – a set of trousers, jacket and hat from brown paper. The gasmasks were home-made – a great big muzzle made from blue flannel which was soaked with carbolic soap. Seventeen folds were made and placed over the nose and mouth. They often smeared their skin with tallow and, not surprisingly, they were often overcome by gas (the only antidote being whisky, often three or four doses a day).

In 1896 Robert H. Sherard revealed to the nation the working conditions in Widnes in his book *White Slaves of England*: 'A mere walk through the yard is dangerous – tanks leak and corrosive fluids drop and drop. One man fell into a vitriol tank and was slowly eaten to death. In Whiston workhouse is a legless man and an armless man, both alkali workers.'

Giving evidence to the 1892 Labour Commission, Patrick Healey, an employee at Hutchinson's, said, 'I work a ten-and-a-half-hour day and my wage varies from £2 to 47 shillings per week. The sanitary conditions under which I work are most defective. The bad gases affect my stomach and prevent me from taking meals without vomiting.' The working conditions brought many men to an early death but they also had to cope with many major accidents that resulted in death and injury. In 1878, for example, 43-year-old Frederick Jones was killed at Gossage's when a large metal cage landed on him. In 1882 Peter Kinsey fell into a vat of caustic soda at Muspratt's. In 1891 James Lynch, a labourer at Sullivan's, was killed in an explosion. Despite some negligence assigned to the factory owners, most of the verdicts at the inquests were of accidental death.

Working life was dangerous but the pollution in Widnes not only affected the workers but their families too. There had been a great increase in the number of alkali works and

Alkali farmers compensation.

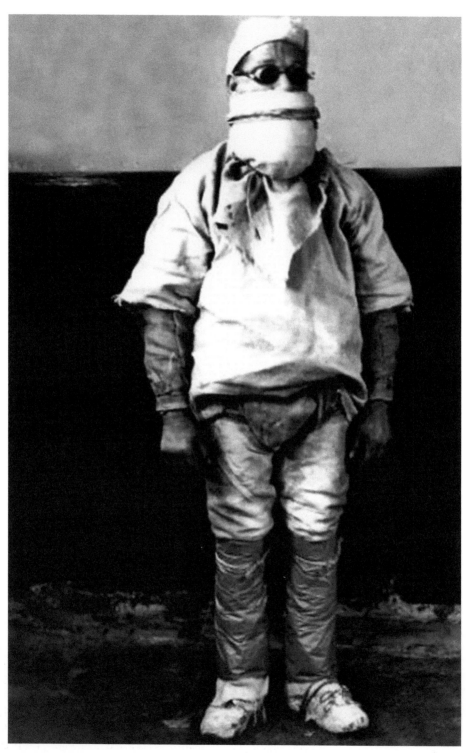

Bleach packer.

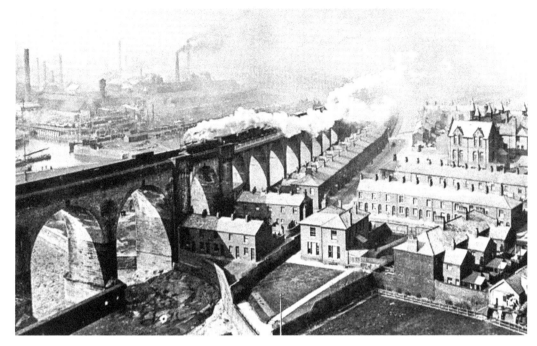

Railway bridge and pollution.

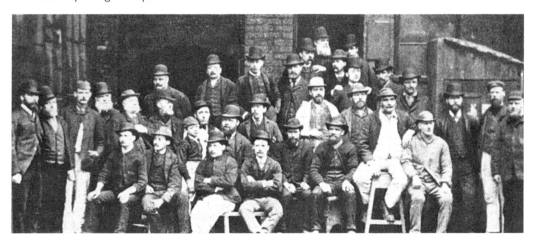

Gaskell Deacon workers c. 1890.

the problem of pollution was so severe that in 1876 a Royal Commission was set up to look into the problem. Many of the major owners gave evidence, and their position was not surprising. They claimed the second Alkali Act had already cost the trade £100,000. It was clear that Widnes and the surrounding areas were suffering badly form noxious fumes and it was stated that a whole field of wheat was destroyed by one escape of chlorine gas. It was also stated that trees were dying in Sefton Park. Edmund Muspratt blamed the pollution problem on one rogue factory, which he refused to name! The previous Alkali Acts were extended and amended by the 1880 Noxious Gases Act. There can be

no doubt that this Act went some way to protect the workers and the public, but there was still a long way to go.

The year 1890 brought a dramatic change when the famous chemical companies of Widnes – Hutchinson's, Muspratt's and Gaskell Deacon – amalgamated to form The United Alkali Company (UAC). The companies were suffering commercial pressure from the more energy-efficient ammonia–soda process of Brunner Mond. The plan was to replace the obsolete Leblanc process plant and to expand the company's range of chemical products.

The new company was keen to create a central laboratory. They appointed Ferdinand Hurter as Head of Laboratory (a role later redesignated as Chief Chemist). He decided the best location was Widnes. The laboratory was completed in 1892 and Hurter and his small staff began their work soon after.

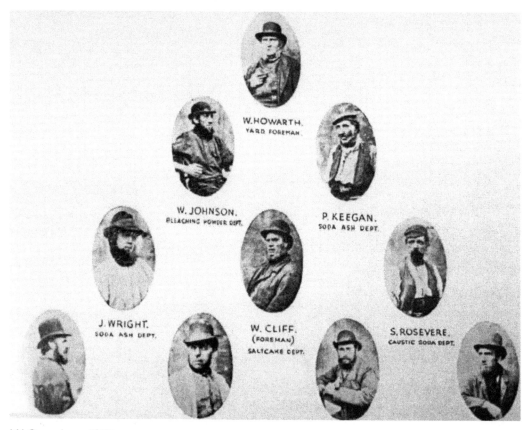

UAC workers, 1890s.

THE TWENTIETH CENTURY: WAR, PEACE AND DECLINE

THE TRANSPORTER BRIDGE

The end of the century brought amazing transformation to public transport. Many boroughs started to plan and build electric tramways; however, Widnes had only become a municipal borough in 1892 and was not in a position to finance such a project. The main transport problem for Widnes was crossing The Mersey. The railway bridge had opened in 1868 linking Runcorn and Widnes but it only had a footway, which was not adequate. The new bridge was planned to make it easier for workers, farmers and tradesmen to cross the river.

In 1899 the Widnes & Runcorn Bridge Company was established under the chairmanship of Sir John Brunner to investigate the options. Their decision was to build a transporter bridge. This would be cheaper than an orthodox type of bridge and the passage of the transporter car could be timed to allow the passage of ships. Construction started in 1902 and, three-and-a-half years later, the Transporter Bridge was opened by Sir John Brunner in May 1905. To celebrate the achievement, workers and their families were treated to a day trip to Frodsham. In 1911 Widnes Corporation took over responsibility from the Widnes-Runcorn Bridge Company. Sadly, this famous landmark was demolished in 1961.

Passengers landed at West Bank, but to reach the town centre was quite a hike up Mersey Road. There was a need for further public transport. In 1907 an open-top double-decker was hired from Burnley and by 1909 Widnes Corporation were operating double-decker buses. These were the first fully enclosed buses to enter service in the world.

Bob Martindale would cross the river to visit other ICI factories. It was fine during the day but if you worked late The Transporter closed at 11.30 p.m. and it costs 5 shillings to call them out. So occasionally Bob crossed the railway bridge by motorcycle, although this was not allowed. It was not easy as the Runcorn side had a difficult flight of steps, but the kiosk man turned a blind eye. It costs one penny each way, two pence for a bike, but you could buy a weekly ticket for 1 shilling for a car. There were often long queues and you could wait two hours to get on. Sometimes people sent someone to reserve a place. Bob remembers that in the Second World War, two GIs were driving by and saw a red light and went right through the barrier and into the mud. A German aircraft raked the bridge with machine gun fire.

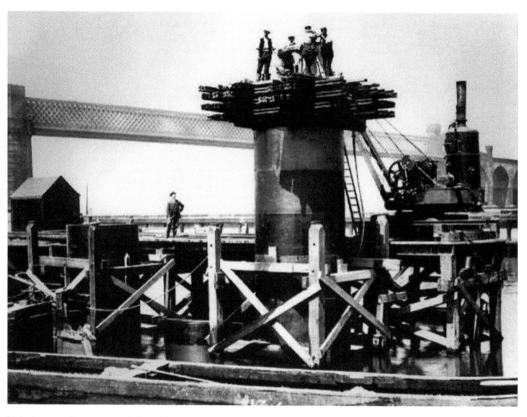

Workers sinking one of the cylinders, 1902.

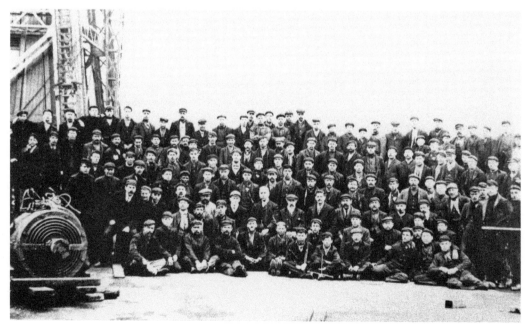

The workers with John Brunner in the centre.

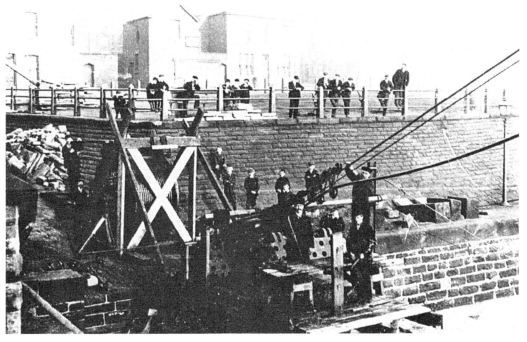

Transporter workers feeding the cables.

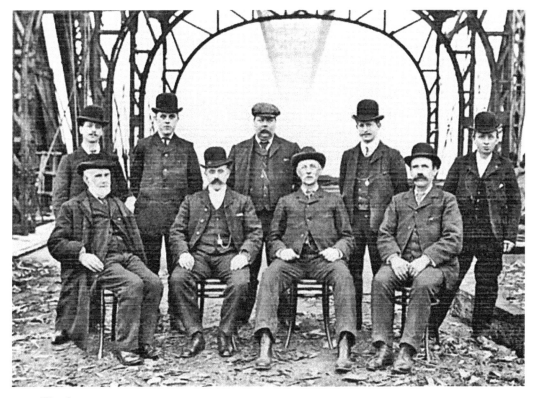

The foreman.

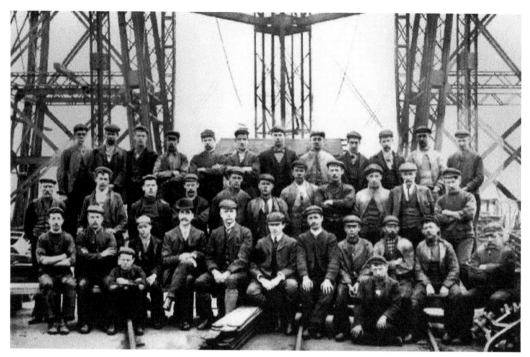

Above: Transport workers, 1902.

Below: The Transporter.

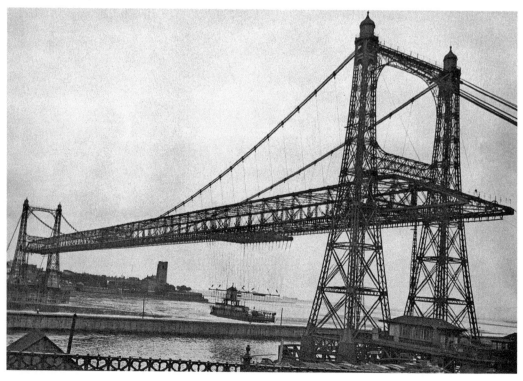

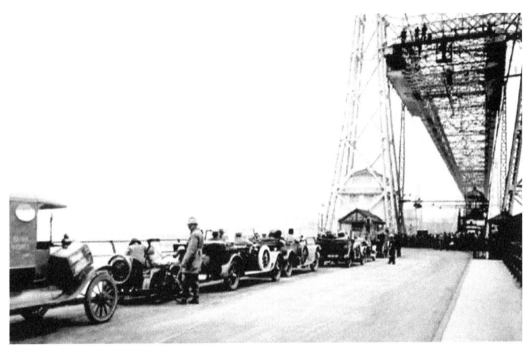

Transporter queues at Widnes.

Official Programme

10-45 a.m. The Mayor of Widnes (Councillor J. H. Collins) and the Chairman of the Transport Committee (Alderman P. Hanley) together with the Widnes Official Party, arrive at the Widnes side of the Transporter Bridge.

11-00 a.m. The bridge car will leave for the last time for Runcorn and will convey the Widnes Official Party to the Runcorn side, where they will be met by the Runcorn Official Party.

11-20 a.m. The Widnes and Runcorn Official Parties will return to Widnes on the bridge car. This will be the last trip.

11-25 a.m. The last trip over, and the car finally in dock, a short ceremony will be held:
The General Manager (Mr. S. Crossley) will present the staff and employees of the Transporter Bridge Undertaking, to the Mayor, to the Chairman of Runcorn Council, and to the Chairman, and Deputy Chairman of the Transport Committee. The General Manager will invite the Mayor to accept on behalf of the Corporation, the driver's handle as a souvenir.

12-15 p.m. At Queens Hall a bronze plaque commemorating the closing of the bridge will be unveiled by Alderman P. Hanley in the presence of the Mayor and the Official Parties. The Mayor will be supported by Mr. R. Graham, past Chairman of the Bridge and Omnibus Committee of the Borough Council, and by Councillor C. C. Posnett, Vice-Chairman of the Runcorn Urban District Council.
A Vote of Thanks to Alderman Hanley will be moved by Councillor H. Scholes and supported by Councillor R. Illidge, members of the Widnes Borough Council. Councillor Illidge will present to Alderman Hanley a small replica of the commemorative plaque.

12-45 p.m. Buffet refreshment.

The programme for the Transporter Bridge official closing ceremony, 1961.

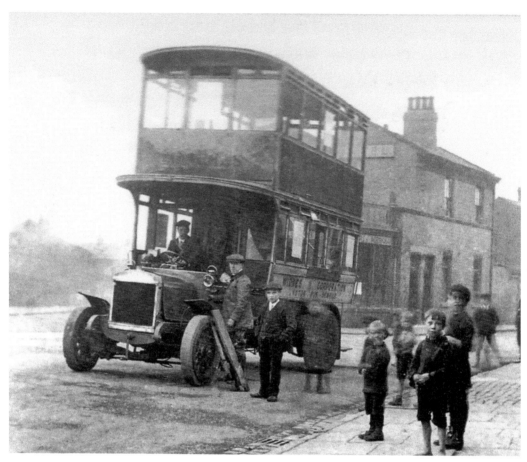

Above: Bus at West Bank.

Below: The modern bus fleet.

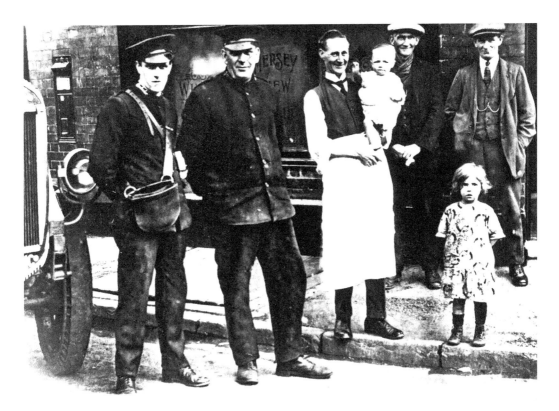

Bus at Mersey View in 1909.

MARGARET COOKE

Margaret worked at the Co-op but once a week travelled on the Transporter to relieve the Runcorn staff. She went on the last trip from Runcorn to Widnes, but it never returned from Widnes; her husband had to pick her up and bring her home on the new bridge!

There were celebrations in Widnes when Princess Alexander closed the Transporter and opened the new bridge. Children lined the streets waving blue white and red flags.

THE FIRST WORLD WAR

When Widnes celebrated the end of the Boer War in 1902 they could not have imagined that in 1914 Britain would be at war again. As early as August 1914 army officers arrived in Widnes to start recruitment and purchase horses for the artillery and transport services. Men who were at least 5 feet 3 inches tall and aged between nineteen and thirty-eight were required. The recruitment office was at No. 76 Victoria Road. Such was the demand for manpower that as early as December recruitment standards were lowered. Foreign nationals were interned and hostility towards Lithuanians and Poles began to show itself again. As they were deemed to be Russian (an allied country) they were excluded from compulsory conscription. Although many of the men did enlist, some made their contribution by working in the local coal mines.

When Britain entered the First World War in 1914, there were serious worries that Britain was ill prepared. How would UAC, one of the largest British chemical manufacturers, and its Central Laboratory respond to the demands of wartime? The war brought a sudden and immediate demand for strong acid for the manufacture of explosives. The UAC's main sulphuric acid plant was at Mathieson Works. Niel Mathieson had opened his plant works on Ditton Marsh in 1876, with lead chambers for sulphuric acid. By 1914 wartime demand led to the installation of four new plants for the contact process, using iron oxide as the catalyst. The war resulted in the reorganisation of the United Alkali companies. In 1915 Mathieson and Golding-Davis were amalgamated as Marsh Works and in 1916 Hutchinson's amalgamated with Gaskell-Deacon. By 1919 UAC employed 5,500 people, of which 700 were women.

In August 1915 the government drew up a list of reserved occupations, which included those working in the alkali industry, reflecting the important part this sector had to play in the war effort. The Widnes paper reported an unusual recruit when Holbrook Gaskell, chief engineer of United Alkali, walked into the recruiting office and offered his services. He passed the medical but of course it was academic as his position at UAC prevented him from serving in the armed forces.

While UAC was not involved in the manufacture of most major explosives, it was asked to devise a new reaction pathway and production plant for picric acid. It was known as a high explosive well before the First World War and became an important ingredient in explosive shells.

Although it is popularly believed that the German Army was the first to use gas, it was in fact initially deployed by the French. In the first month of the war, August 1914, they fired tear-gas grenades against the Germans. Nevertheless, the German Army was the first to give serious study to the development of chemical weapons and the first to use it on a large scale and, unfortunately, chemical agents became an important part of warfare. After the Germans used gas at Ypres, UAC were under pressure from the War Ministry to develop chlorine,

NOT TRANSFERABLE.

This is to Certify that P. Hunt employed by THOMAS BOLTON & SONS, LD is authorised to wear War Service Badge numbered 32948450 long as he is employed on work for war purposes by the employer above named

D. Lloyd George

P.T.O.

Employee certificate.

The Widnes Foundry Co.

WIDNES, LANCASHIRE,

MANUFACTURERS OF ALL DESCRIPTIONS OF

CHEMICAL MANUFACTURERS'

PLANT,

INCLUDING

Decomposing Pans, Caustic Pots, Boat Pans, Salting-down Pans and Drainers, Crystallizing Pans, Lixiviating Vats, Wrought and Cast Iron Stills and Retorts used in the Manufacture of Muriatic and Nitric Acids.

WROUGHT AND CAST IRON STILLS, &c.

For the Manufacture of Benzole, Aniline, and other products
of Gas Tar.

STEAM BOILERS.

REVOLVING BLACK ASH FURNACES.

STEAM AND OTHER HOISTS.

Apparatus for the Manufacture of Salt Cake by Hargreaves & Robinson's Process; and Apparatus for Weldon's, & Deacon's Patent Chlorine Processes.

ANVIL BLOCKS

AND

HEAVY CASTINGS GENERALLY.

Above: Poster for the Widnes Foundry in 1876.

Right: Recruitment image.

RECRUITING IN WIDNES.

WORKS OFFICIALS ENLIST AS PRIVATES.

MR. HOLBROOK GASKELL CAPTAIN SPARROW'S FIVE HUNDREDTH RECRUIT.

A gratifying incident occurred on Wednesday morning at the Widnes Recruiting Office and one which should have an exemplary effect upon enrolment.

On Tuesday night it was noted by the office staff when the closing hour arrived that the recruits who had been attested since Captain Sparrow took charge on June 8th last numbered 499. Early next morning considerable speculation was aroused as to the possible identity of the five-hundredth recruit.

The interesting speculation was dispelled by Mr. Holbrook Gaskell, chief engineer of the United Alkali Company, walking into the office, followed by Mr. W. Bottomley, another official. Mr. Gaskell was duly passed under the medical test, measurement and attestation and enrolled as a private, together with Mr. Bottomley. Each duly received 2s. 9d.—one day's pay as an infantryman and one day's rations. To mark the occasion, Captain Sparrow asked Mr. Gaskell's acceptance of a walking stick as a gift from himself. Both gentlemen are, of course, engaged on important munition duties, but in consequence of Lord Derby's request that munition workers should enroll under his recruiting scheme, they presented themselves at the Widnes office.

Recruiting is proceeding at a steady rate in Widnes, and so far the present week is the best that has been recorded under Lord Derby's scheme.

phosgene, mustard gas and other poisonous gases. We now react with horror to the use of gas but it must be remembered that chlorine (bleaching powder) was a vital disinfectant which also saved the lives of many troops during the war. It has also played an important role in medical science. It is not only used as a disinfectant, but it is also a constituent of various medicines. The majority of our medicines contain chlorine or are developed using chlorine-containing byproducts. The first anaesthetic used during surgery was chloroform.

The war brought new industries into the town such as Everite, providing asbestos cement sheeting. This is another product now viewed with horror, however, when it was first introduced it was described as 'a building material which the fiercest fire cannot pass' and was a great contribution to fire safety in buildings.

Widnes Foundry was heavily involved in the war effort. Large quantities of light railway sleepers and steel hut material were supplied to the British government. Other work was carried out for the British Admiralty through Marconi, manufacturing the steel masts which were at that time being used for electrical transmission. The firm made thousands of steel trench covers and floor sheets for the French government, for which a special pressing plant had to be used.

The foundry was first started in 1861 by William Robinson, who also had a foundry in St Helens. He had started his working life as a lowly apprentice blacksmith but through talent and hard work became a successful businessman in his own right. He was commissioned to build Hutchinson's No. 1 Works for the chemical industry, and was also commissioned by Hutchinson to build the first private locomotive used in Widnes. With the expansion of industry in Widnes his business thrived. His many projects included tunnel segments for City and South London Underground Railway, and cast-iron piers were installed at Mumbles, Colwyn Bay, Great Yarmouth, Morecambe, Ramsey, Blackpool, New Brighton and Havana. Thirteen-inch mortars, the largest ever made in those days, were produced for the Crimean War, and cast pipes for Liverpool Corporation water supply from Lake Vyrnwy.

Widnes suffered a Zeppelin attack in 1918 and two bombs dropped on Bold; fortunately there were no casualties. However, the raid moved onto Wigan where, sadly, seven people were killed and twelve injured.

The end of the war was warmly celebrated in Widnes. The mayor, Alderman Davies, announced the wonderful news from the steps of the Town Hall and Bolton's sounded their buzzer, which was greeted with a cacophony of buzzers and hooters from the other factories. The town had lost a generation of their young men and in July 1919 the whole town turned out for a peace march through the town. The war memorial in Victoria Park listed the names of 818 Widnes men lost.

Lloyd George promised 'a land fit for heroes' but many of the soldiers returning to Widnes after the war found themselves unemployed. There was a housing shortage and inflation was rife. There were now large numbers of widows and fatherless children with no state aid to support them, as well as many men who returned from the horror of war with severe injuries and lasting mental health problems.

The year 1919 saw the first Labour MP, Arthur Henderson, elected in Widnes. By 1920 there were almost 3,000 unemployed. The slump resulted in lay-offs all over Widnes. UAC closed for ten days over Christmas, as did Widnes Foundry and Gossage's. Women had been working during the war and now there was pressure for their jobs to be given back to men. To make matters worse, the factory owners were now proposing to lower wages.

In 1920 an increasing need for electric power prompted United Alkali to build a central power station. West Bank Dock was chosen as the site, since power and water were required for the turbine condensers. Originally it supplied only Pilkington Sullivan Works, but gradually the other UA companies used its power supply. It closed in the 1960s.

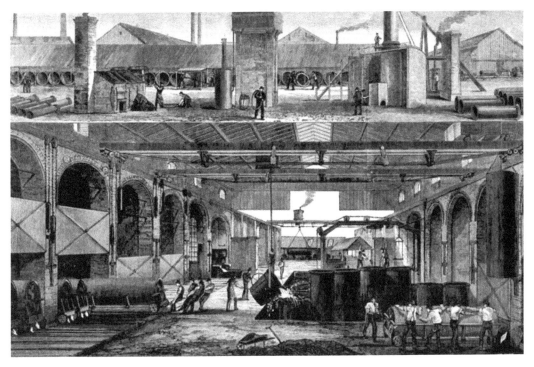

Pipe Foundry, Widnes Foundry.

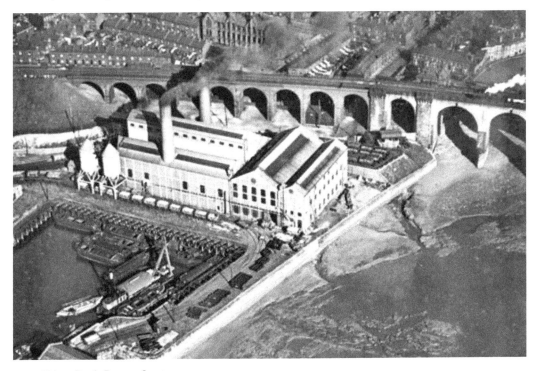

West Bank Power Station.

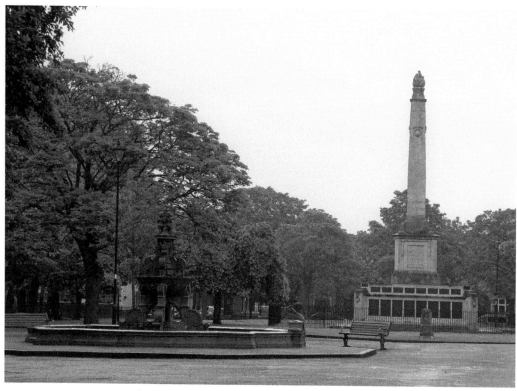

War memorial and Gladstone fountain, Victoria Park.

THE FOUNDING OF IMPERIAL CHEMICAL INDUSTRIES

The year 1926 was a significant year for the British chemical industry which saw major rationalisation of the industry with the formation of Imperial Chemical Industries (ICI), through the amalgamation of UAC with Brunner Mond, Nobel Industries and British Dyestuffs Corporation. This was to compete with other emerging large companies such as IG Farben and DuPont. During the First World War, UAC had been devoting all of its time to the war effort. The company now needed to concentrate on production for commerce and industry. ICI would now take its place as a world leader in the manufacture of chemicals. The company was committed to put research and development at the forefront of their business strategy.

THE SECOND WORLD WAR

As early as 1935, fear of war was again gripping the country and Widnes, with its major industries, would be a prime target for air attacks. The government was already sending circulars to local authorities on the dangers of air raids, and by 1937 Widnes Town Council were discussing local defence. Local factories were beginning to train groups in first aid and gas precautions. Everite started to provide information on air-raid precautions and classes were held at the factory on gas warfare.

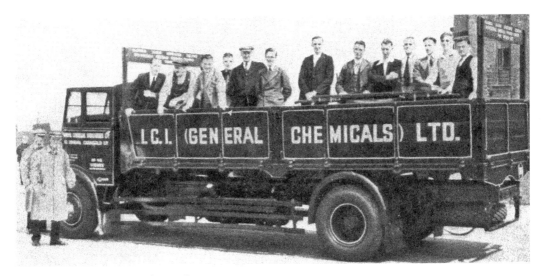

Gaskell Marsh ARP first aiders.

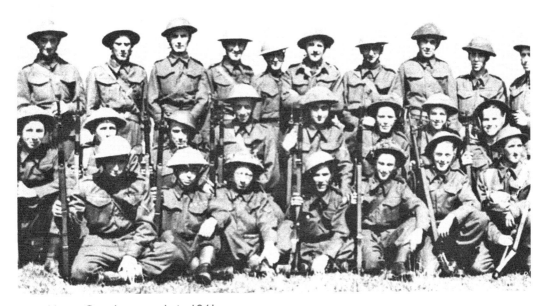

Home Guard on parade in 1941.

Despite Joseph Chamberlain's assurance of 'peace in our time' the country prepared for war. Barrage balloons were placed at significant locations. In September 1939 children were evacuated and later, when the expected air raids failed to happen, they slowly began to return. Food rationing began and allotments appeared all over Widnes. Once again women took over work essential to the war effort.

In 1940 a 1,000-ton bomb fell on the Everite works but caused no injuries. In March 1941 a German aircraft was shot down on the ICI recreational sports field. May 1941 saw heavy bombing in Liverpool and the skies of Widnes were red with fire.

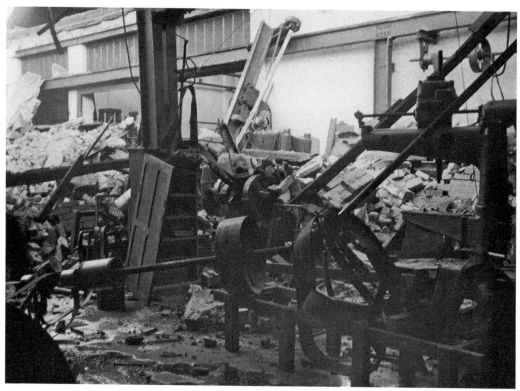

Bomb damage at the bus depot in 1943.

After a period of peace, nine people were killed in Widnes in October. The bus depot was hit in 1943.

Despite the fear that the chemical factories of Widnes would suffer heavy damage, in fact only the Central Laboratory in Waterloo Road suffered bomb damage. Despite this setback, the laboratory was able to continue research, which was crucial for the war effort.

Diana Leitch has recounted the important work her father did during the Second World War:

In 1936 he was appointed to the new research group at the laboratory in Widnes. The scientists worked on the separation of the Uranium Isotope. He was never able to talk about it as he signed the Official Secrets Act. The cover story was that they were working on Anthrax and Phosgene. He used to travel to the Rhydymwyn Valley Works site near Mold where, in utmost secrecy, further development work was taking place. ICI suggested Rhydymwyn because it was not far from Widnes and Runcorn. It was inland and relatively safe from air attack because the site was in a valley, heavily wooded and, from the air, looked no different from other nearby valleys. In 1943 the project moved to the US and was known as 'The Manhattan Project'.

ICI suggested Rhydymwyn because it was not far from Widnes and Runcorn. It was inland and relatively safe from air attack because the site was in a valley, heavily wooded and, from the air, looked no different from other nearby valleys. In 1943 the project moved to the United States and was known as 'The Manhattan Project'.

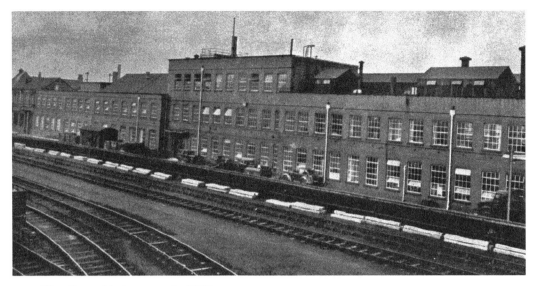

The Central Laboratory in 1949.

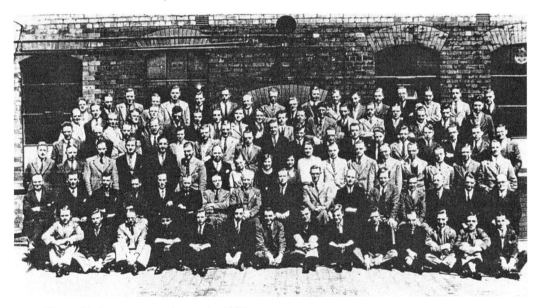

Central Laboratory employees in 1936.

It was only in 1945, when RMS *Aquitania* docked at Southampton, that it was revealed that elite scientists from Widnes were returning to England after working on the atomic bomb in America. After the war this research was continued at Rocksavage Works, and was invaluable for Britain's early atomic energy programme.

Widnes was also the birthplace of Roy Chadwick, who was born in Marsh Hall Farnworth in 1893. He became chief designer for Avro's and was responsible for designing the famous Lancaster bomber, which was crucial to the RAF's success in the skies and of course played its part in the famous Dambuster Raids. Sadly Roy was killed in 1947 when on a test flight at Woodford Aerodrome.

Hutchinson Street looking towards the Waterloo Centre (previously Central Laboratory).

WIDNES FOUNDRY

Once again Widnes Foundry was crucial to the war effort. On the outbreak of the Second World War the foundry capacity was increased by the erection of a new bay for heavy castings. Further extensions shortly afterwards provided additional floor space of 15,000 square feet. During this period extra overhead travelling cranes were installed, including two of 30 tons capacity, and special new machine tools were laid down.

The specialised nature of the equipment produced at the company's foundries was well suited to the demands of wartime, and the foundry and machine shop were continuously occupied with government commissions of the highest priority. Chemical plants of every description were in urgent demand and in this field Widnes Foundry's experience and productive capacity was extended to the full to provide the equipment required.

In the constructional department equally varied equipment was manufactured, including parts for Bailey Bridges, tanks for 'Bombardon' contract, prefabricated ship units and aerial gantries, portable cranes for the Admiralty and Royal Engineers, main booms for conveyors for the Ministry of Supply, and gun settings for the Navy.

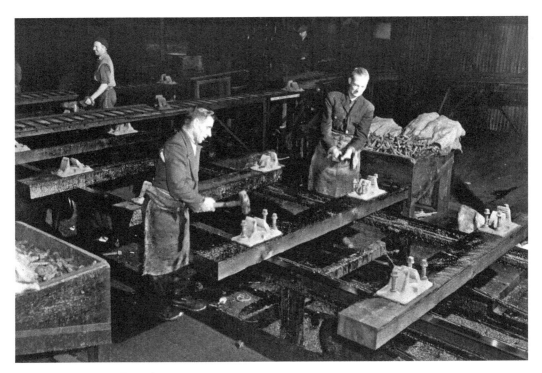

Above: Widnes Foundry.

Below: Welding at Widnes Foundry.

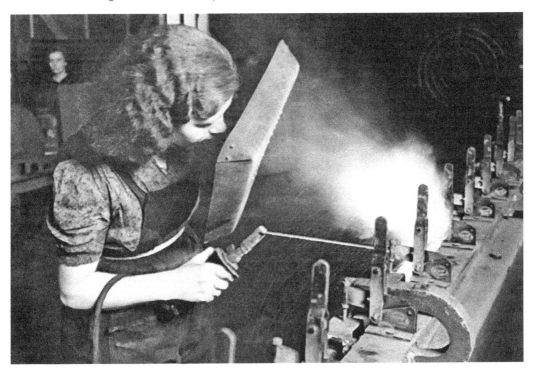

THE POST-WAR YEARS

After the war men and women returned from overseas and housing was in short supply. Much of the housing stock was not of a good standard and was overcrowded. Widnes Corporation set about building new housing and many of the old houses in West Bank, Ann Street and Lugsdale were demolished. Air pollution still troubled the town and smokeless zones were introduced.

In the 1950s there were still forty-five major chemical companies in Widnes, but the 1960s saw the decline of the chemical Industry in Widnes. The LeBlanc days were finished and the

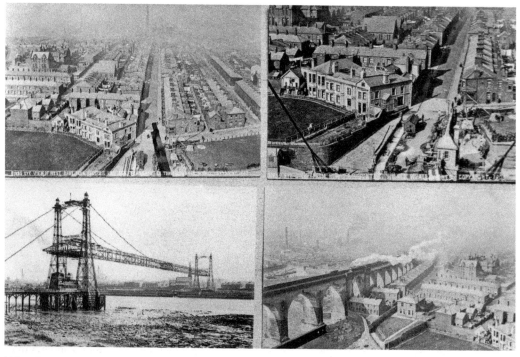

West Bank.

Solvay process was booming in Northwich and the Castner-Kellner process was flourishing in Runcorn. Slowly, heavy industry was declining in the town and inevitably this resulted in unemployment.

There remained, however, some very successful chemical companies, as well as Thomas Bolton & Sons copper works in Hutchinson Street.

THOMAS BOLTON & SONS

The Mersey Copper Works were built in 1881 for smelting and electrolytic refining. The firm grew out of a business producing metal buckles into one of the world's leading wire (especially electrical wire) manufacturers. Important stages in the company's growth were marked by the introduction of cold drawing and continuous wire drawing to meet the demand for long lengths of high-conductivity, high-tensile strength copper wire for the telegraph and telephone industries. It was taken over by the cable companies in 1961.

In 2014 the last of their copper works in Staffordshire went into administration, losing 110 jobs.

The Widnes factory was painted by L. S. Lowry in 1956, as the artist was fond of painting industrial scene.

PILKINGTON SULLIVAN

This company was created from the amalgamation of the Pilkington and Sullivan works in 1921. Bob Martindale recalls working there:

I started work as an office boy at Pilkington (Pilk's) in January 1945 aged 14. I was in this position for eighteen months until I was given a trade for a six-month trial period. Then, when I was 16, I signed my indentures for a five-year apprenticeship. I was associated with all the products – caustic hypo and bleach inorganic and organic. In 1945 the liquid phosgene plant had closed and chlorine inorganic products were shut down in the 1970s. I experienced the manufacture of Monoma for making Perspex. This was an essential product for the manufacture of wartime planes. It was a very toxic process, workers needed sealed chamber gasmasks, compressed air and a safety harness roped to three men to ensure safety. I remember a bad accident to a fitter; he forgot to remove his gloves when removing his gasmask and he immediately collapsed. Thankfully he survived. When he returned to work, scientists came to speak to him about his experience.

I later worked with Bipyridile. The first pilot plant was built at Pilkington's on the edge of the tip. In the late 1960s the plant caught fire and it was shut down for a long period. I worked on the plant until 1983 when I transferred to the aloprene plant, which went into the production of Dulux paints. The Paraquat was built in 1975 and remained in production until the factory closed. Pilkington-Sullivan was a very busy works with lots of plants but slowly plants closed until full shutdown in 1998.

The chlorine process built at Pilkington Works (the Gibbs Cell process) was American. Pilkington's had built the first part during the war – May 1915. It was rumoured that the commissioning information and drawings to start production in Widnes went down with the *Lusitania* in May 1915 – this delayed full production for a year.

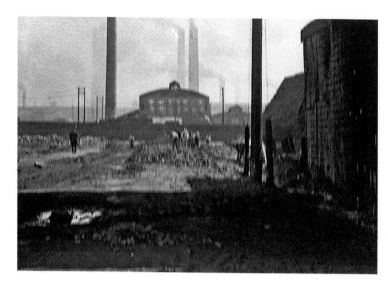

Left and below:
Bolton & Sons in
Hutchinson Street.

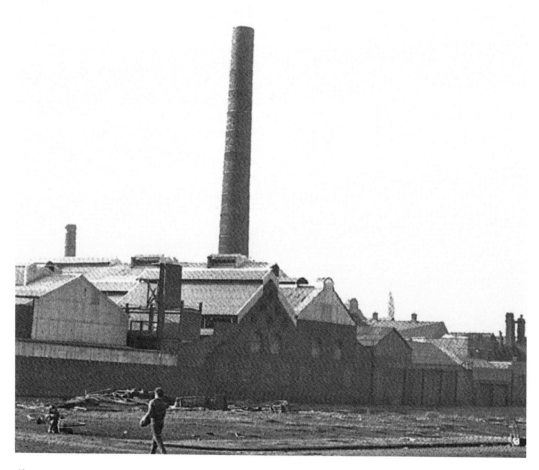

Above and overleaf: Thomas Bolton & Sons.

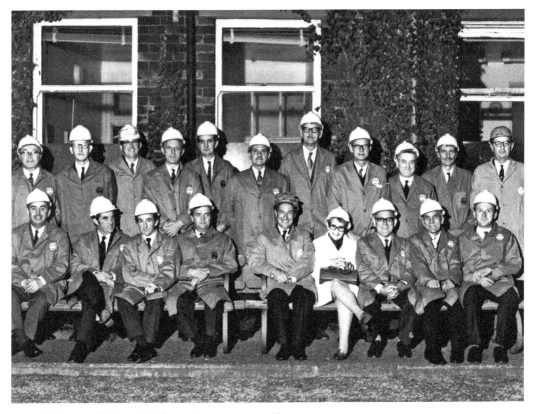

Pilkington Sullivan visit from the town council.

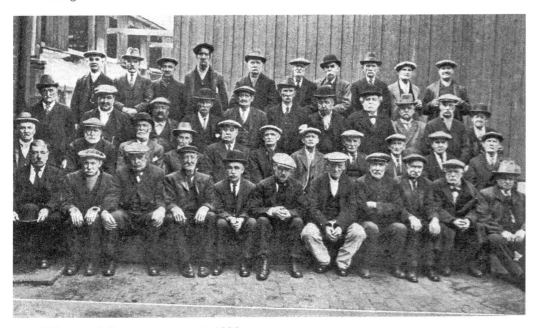

Pilkington Sullivan pensioners in 1928.

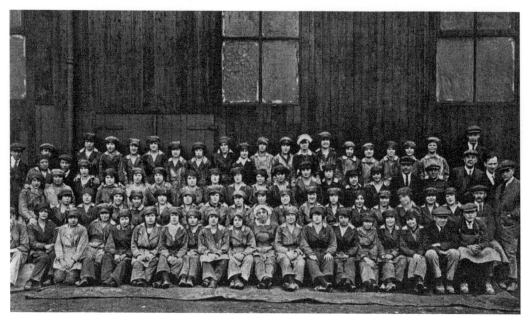

Above: Pilkington Sullivan packers, 1926.

Below: Pilkington's workshop, 1930s.

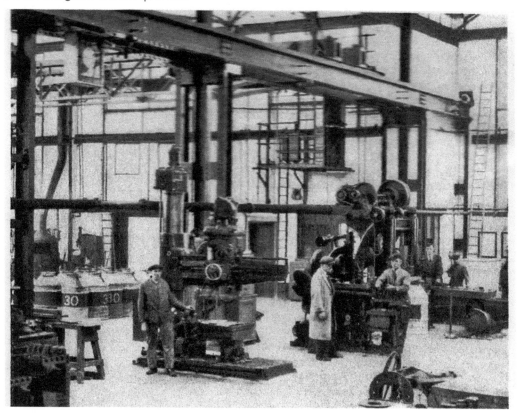

BOWMANS CHEMICALS LIMITED, MOSS BANK WORKS

The company was started in Warrington by Robert Bowman, a chemist from Glasgow, and moved to Moss Bank Widnes in 1915. It was here, on 25 October 1915, that Bowman carried out his first attempt to make lactic acid. Widnes helped in the war effort as lactic acid went into the making of lactates used in making the protective wings of aircraft.

Bernard Keogh recounts his career at Bowmans, from junior office boy to becoming the last Works Manager:

I joined Bowmans in 1961; it was a forward-thinking company and I was encouraged to go to college, but I had enough of school so I opted for working on the chemical plants on the excellent wage of £8 a week! I enjoyed working in the pilot plant, working with research chemists. Once again I was encouraged to go to college and finally I agreed when I heard I would receive one-day off with pay. I was awarded City & Guilds with distinction in Chemical Plant Operation and this success encouraged me to go further – ONC, HNC and thirteen years after starting my studies I was awarded a Diploma in Industrial Management. I was now a manager and I was able to take a more modern outlook to management with a fresh outlook. Bowmans manufactured some unique chemical products. They were pioneers in the lactic acid industry and one of the uses was in Fox's Glacier Mints, which made the distinctive mint clear so you could not see the polar bear stood on the mint. Malic acid is the acid of apples and was used in soft drinks and cider manufacture.

Bowmans was taken over by Croda in 1968 and became the largest British-owned chemical company, with 280 employees at the Moss Bank site at its peak. The company

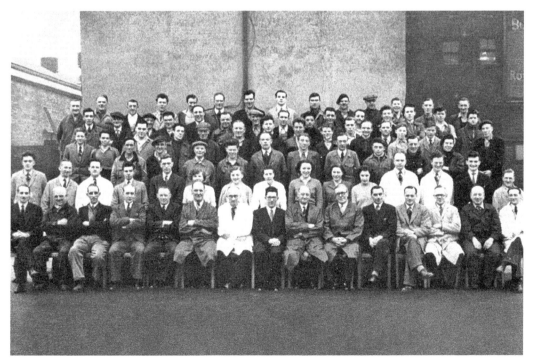

Bowmans staff in 1955.

The Staff and Employees in 1955

Front Row: *Left to right*—R. A. Williams, J. D. Derbyshire, T. Murray, H. Ireland, B. Miller, L. Smith, C. G. Childs, D. Mather, S. H. W. Pert (*Managing Director*), E. G. Turner (*Chairman*), A. Clark, E. A. Newall, A. James, H. Mousdell, J. Calland.

2nd Row: *Left to right*—I. Boyle, S. Kershaw, T. Reid, R. Thornett, J. Bibby, Mrs. M. Jackson, Miss A. Greenfield, Miss K. Paton, Mrs. J. O'Neill, Mrs. B. Taylor, Miss D. Bradley, A. Beesley, J. McNerney, F. Plumpton, W. Keeling.

3rd Row: *Left to right*—R. Cairns, C. Warren, H. Hodgkins, T. Purcell, Jnr., E. O'Neill, R. Harris, M. Littlemore, W. Lamb, R. Hillyer, C. McCormick.

4th Row: *Left to right*—D. Wagstaffe, B. Gilmore, J. Davies, D. Meaney, T. Purcell, Snr., J. Lamb, T. Bonnon, R. Twigg, R. Jackson, B. Arnold, J. Buckley, N. Smith, W. Dixon.

5th Row: *Left to right*—C. Gerrard, P. Kelly, H. Gordon, A. Brown, H. Campbell, J. Singleton, H. Polhill, H. Turton, K. Whitfield, S. Harris, T. Marsh, F. Roylance, R. Graham, B. Devaney, W. Burke, J. Houghton, J. Murray.

Back Row: *Left to right*—T. Dyer, G. Fazakerley, J. Parry, F. Tickle, T. Hankey, K. Marshall, F. Merrill, R. Smith, L. Smith, Jnr., M. Williams, S. Plumpton, P. Houghton, R. Ashton, C. Helme.

Not Present: C. C. Posnett, W. H. Bellamy, J. A. E. Howard, G. C. H. Clark (*Directors*); C. F. Appleton, H. Badger, A. Barber, B. Boulton, G. Burton, D. Davidson, J. Greenfield, D. Harris, N. Jones, C. Moorton, J. O'Neill, K. Rawson, A. Rickard, E. Sinnott, W. P. Stedmond, A. Wood.

Bowmans staff details.

developed niche markets. Bowmans factory products declined and in 1990 were down to seventy employees and the company was struggling. In 1991 I became Works Manager and Croda invested in a modern plant and with some rationalisation the company became successful again, which lasted until my retirement in 2005 and the closure of the site after 100 years of manufacturing chemicals.

PETER SPENCE LTD

Peter Spence took out a patent on the alum process in 1845. His works in Manchester produced alum and other chemicals. Like Gossage, he was a keen inventor, and took out many patents. In 1887 he was in dispute with A. G. Kurtz and Co., who won an action against him. He left Manchester and in 1919 he opened works in Farnworth.

Ralph Topham joined Peter Spence Ltd for an annual salary of £500 in 1953, as he thought there were better prospects in a bigger company. Soon after, he moved from Liverpool to Widnes. He worked on chemical plants that made a variety of small products including Alumina White 1 and 2 for the plaster business, TPO (Titanium Potassium Oxalate) used in the leather industry, and titanium sulphate. For the latter, drums of potash were shovelled into a bath heated with coke, which resulted in rather dangerous bubbling molten potash. Health and safety was not high on the agenda. In 1954 he was promoted to the Neosyl plant. The Sulphuric Acid Plant polluted Widnes on a Sunday afternoon and the Plant Manager, Harry Ince, was moved to another plant. This resulted in a fast promotion for Ralph. Despite not having the experience, Ralph was appointed Plant Manager of the SC1 plant and later the SC2 Pyrites Plant (SC stands for Simon Carves, who designed the plant). He was surprised to find no plant-operating manual so he learnt on the job and took it upon himself to produce a manual. In 1964 a modern plant for the manufacture of sulphuric acid was commissioned and built. This

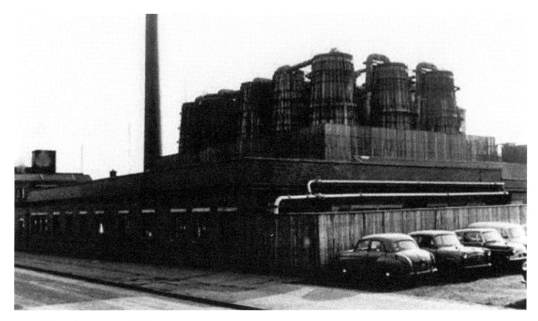

Peter Spence, *c.* 1950.

displaced all the other, smaller plants. Ralph was made Plant Manager of this new Acid Plant.

In 1961 the company was taken over by Laporte. Chris Lewis joined Laporte in the Research Department in 1969 in Widnes, but worked at various Laporte sites in the United Kingdom in the 1970s. He returned to Widnes in 1978 to take over 'Ralph's' Acid Plant when Ralph was appointed Safety Manager. Ralph was a great support to Chris and for the first few weeks was willing to come out to help at midnight if needed. The Acid Plant was a major plant for Laporte, manufacturing 450 tons of sulphuric acid a day, which was used to make many other chemicals. The process also generated steam and electricity for the rest of the site. The plant closed in the 1990s.

Chris had previously moved to set up a Purchasing Department during a rationalisation in 1989. During this rationalisation two in three employees left the site – all were voluntary as staff were offered excellent terms, including a pension at 50. A few years after Chris himself had moved from the Acid Plant he was asked to look at costings for the viability of the plant and saw they were incorrect. He pointed it out and the plant closed within a year. It was still called the 'new' Acid Plant when it closed!

Martin Griffiths recalls working at Laporte:

I went to University at Sheffield and studied chemistry. I was looking for a job and it was obvious to come to the heart of the chemistry industry, which was Widnes. My first job offer was Laporte. I was invited to interview and stayed at The Hillcrest – it's still going strong. The following morning I was taken to The Woodlands and had Smörgåsbord for lunch – very continental, never seen that in Yorkshire. I started in 1977: I had digs in Birchfield Road. It was the time of the Ted Heath government – three-day week – high inflation and frequent power cuts despite being in shadow of Fiddlers Ferry Power Station. My first pay rise was 16 per cent, such was the inflation. I worked in R & D on peroxides, which was made in Warrington, and sulphides, which were made in Rotherham. I had to spend a week in a small hotel with coin

Jack Douglas, Walter Boulton, Tommy Appleton, John Roughley, John Jones and others receiving their winnings (Pyrex).

meters – it was very cold. Laporte organised an induction programme touring the various sites. While we were touring the Widnes site the fresh-faced graduates were steered away from a leak of Oleum – a very aggressive acid, worse than sulphuric acid.

There were great opportunities for sport at the company. There was a sports and social club at the Widnes site and a bowling green at the R & D offices. We had a full hour for lunch so we played bowls – that was where I met my wife. One game she stumbled and put the bowling bowl through the hut window. We also played touch rugby at Warrington and played cricket at Moorfield Road. We also played squash. The smaller companies do not organise sports now. Sports are only played at clubs such as The Wids.

Life was changing in 1960s' Widnes. The Beatles played at the Queen Hall in 1962 and 1963. Mini skirts were everywhere. The year 1963 saw Vince Karalius lead the 'Chemics' out at Wembley to win the Challenge Cup, their first trophy success in eighteen years. Working lives were changing, too. Lighter industries were coming to Widnes and the heavy chemical works were disappearing.

THE GOLDEN WONDER FACTORY (AKA 'THE CRISPY')

Cathy Rossi recalls working at 'The Crispy' and how it transformed women's lives:

My mum got a job and within months of the factory opening, most of the women in the area went to work there, and it was a great opportunity for women to have some independence and earn their own money. The wages were good and because it was shift work, 6 p.m. to 10 p.m., the fathers could take over childcare when they came home from work. Lives were transformed. Families were getting affluent because of 'The Crispy'. Suddenly everyone was buying three-piece suites and fitted carpets, which had been unheard of. There was a great social life. The women took an annual trip to the Edinburgh Tattoo and organised visits to hotels and restaurants. There were socials in the canteen – singing and dancing and a bar was set up.

I had worked a George Henry Lee in Liverpool but found the travelling difficult. I was offered a job in the lab at 'The Crispy'. In those days it was easy to get the job if your family worked there.

Unfortunately there was no day release for women. This was only offered to the young men. The cooks who cooked the crisps were the gods. The lab sampled the crisps, checking the quality and picking out bad ones as they passed through the conveyor belts. The crisps then went through to the factory, where flavours were added. The machine would weigh and cut the crisps, and then they passed through to the packing area.

Lots of men came down from Scotland to set the company up and being away from home there was lots of womanising. It was a very happy place to work and childcare was solved by passing babies from shift to shift. There were lots of visits to the pub after the night shift and, inevitably, there were many workplace affairs. Sometimes husbands would arrive and fights would occur, and sadly this resulted in many broken marriages. The cloakroom was quite a marketplace. It was full of catalogues and you could buy anything at work – fashion, baby clothes, jewellery – all delivered to work. Towards the end the factory became unionised. There were militant strikes and in 1999 the management closed the factory.

This led to the loss of 540 jobs and an institution was lost to Widnes. The company announced a shift in production to two other sites in Scunthorpe and Corby.

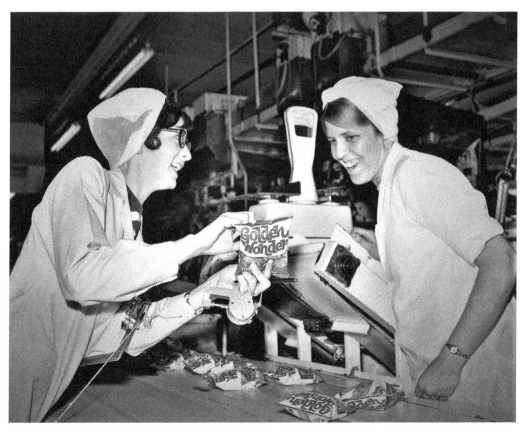

Golden Wonder quality control: Norma Naylor and Jean Crank.

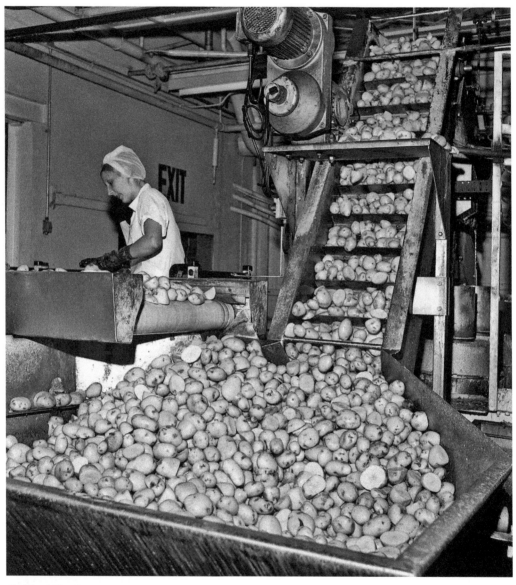

Golden Wonder potatoes.

Jim O'Neill remembers the good times at 'The Crispy':

You could get a job in a week easily and find another if you did not like it. I have been promoted, sacked and unemployed. I have been lucky to have had several jobs but the best was at 'The Crispy'. I worked there as an engineering stores controller, then on the production where the ladies outnumbered by the men – three to one. There were great times, particularly at Christmas. Unfortunately the great parties at Golden Wonder had to be abandoned as a worker got on his motorbike and crashed, and a couple were found in the grotto (they were not opening Christmas presents!). The town is now much poorer not to have such large employers.

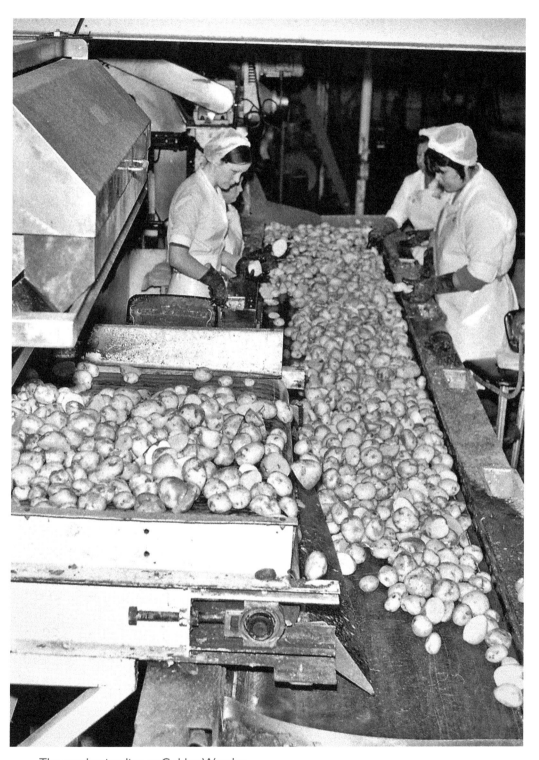

The production line at Golden Wonder.

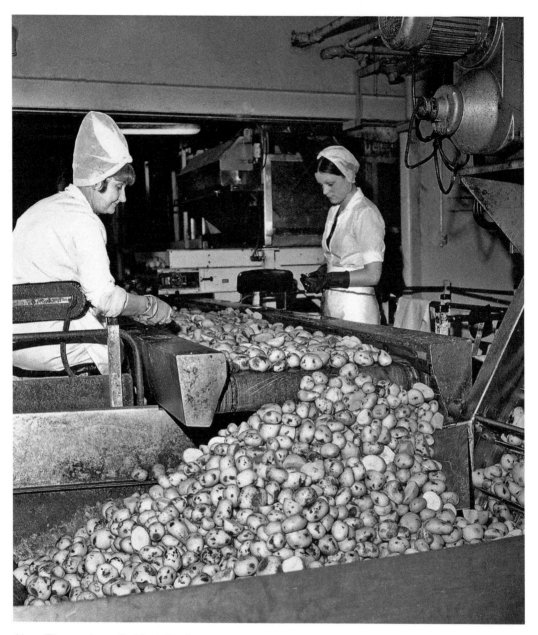

Above: The cooks at Golden Wonder.

Opposite above: Golden Wonder mayoral visit: Ken Owen with Stan Bowen.

Opposite below: Golden Wonder retirees Mrs Parker and Betty Grice.

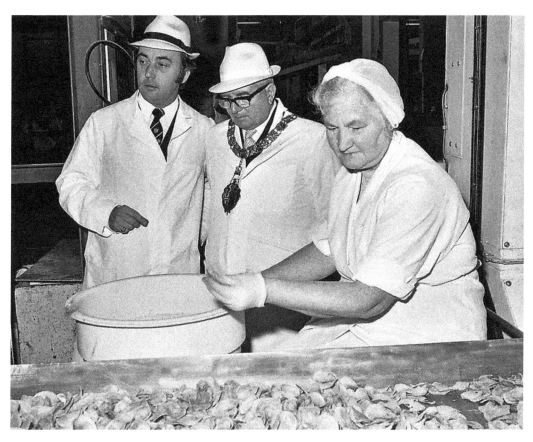

MONTAGUE L. MEYER

Widnes was a centre for the timber trade and there were a number of companies trading in the town. The main timber firms in the 1960s were Meyer's, Evans and Southern's. Meyer's had flourished through both world wars, when home-grown timber provided an answer to the limited amounts of imported timber. In the 1990s Meyer's took over Evans and moved into Evans' yard. After a couple of years Finn Forest took over and Meyer's left Widnes.

Ron Lamb worked for Meyer's from around 1965 to 1996:

I started in 1965 and worked for thirty years at Montague L. Meyer. I did various jobs: sorting timber for types and quality, driving fork lift trucks and supplying doors, windows, etc., to building sites. Timber was coated (tanalised) for fencing and sheds and then pressurized to completely soak through, for maximum protection. At this time there were lots of new estates going up which kept the company busy. I most enjoyed getting out and about delivering timber all around the region as far as Yorkshire and the Lake District and Shropshire.

Often I would arrive at a small village with very little address information. In these small villages I could ask anyone where they lived and instructions were given straight away.

Wood was imported from Sweden and Russia. Ditton Road was a hive of activity with lots of timber companies. It was a good social life. After thirty years I was feeling it was time to go. When I heard that some of the younger men were facing redundancy I asked the manager if I retired, would it save someone else's job? I was happy to be able to help a younger man. I did not regret it although I missed my colleagues, but I still keep in touch.

FIDDLERS FERRY POWER STATION

Fiddlers Ferry Power Station was opened in 1971 by CEGB. It is proposed that the United Kingdom's remaining coal-fired power stations will be shut by 2025, with their use restricted by 2023. An iconic site will be lost.

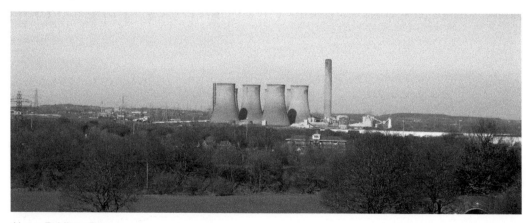

Above: Fiddlers Ferry.

Opposite above: Fiddlers from Victoria Park.

Opposite below: West Bank and Fiddlers Ferry.

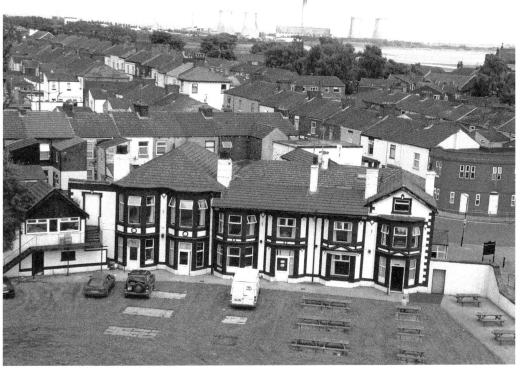

Dave Robertson remembers his time at the power station:

As soon as I was eighteen I went to work at Fiddlers Ferry as a junior steel erector. You were supposed to work at floor level at first, for safety reasons, however, on the first day I was 250 feet up! I was frightened to death. A man said, 'How long have you worked here?' When I said that it was my first day he was horrified and told me to get down. I didn't, and after a week I could do it. I was on full money – £22 a week.

I went to work first on a push bike but after six months on such good money I bought myself a brand new Cortina which cost me £900 – a lot of money!

When the buzzer went I asked, 'What's up?' I was told a man had fallen and I asked, 'What do we do now?' 'We all go to the pub.' There were many fatalities – eleven killed in seven years. My mum asked me, 'Are you sure you have the right job?' There was no health and safety at the time. No boots, goggles or helmets – these came in later. The pipes were lagged with blue asbestos and it would be mixed up and thrown around like snowballs. The workers would go home with asbestos on their overalls. A very bad thing! When the danger became known then full precautions were taken. Health and safety brought the accident rate down but the site lost some of its camaraderie.

There were many characters. Manchester Mick – an Irish fellow – arrived at work with large cut on his head. His wife (Scotch Annie) had thrown his dinner at him – a tin of corned beef.

One day I was 100 foot up on a beam when I looked behind me to see a welder; much to my surprise he was a Red Indian. He had worked on the skyscrapers in America. He was quite an entrepreneur; he raffled his car – a Zephyr – for £1 a ticket and sold 800 tickets.

An Irish man with a moped left work and when he found it would not start he was offered a tow and tied the rope around his waist, the car dragged him along the road and he ended up in hospital. Scaffolder 'Lincoln Mick' was very mean – the bread at meal time was free in the canteen so he only had bread for his dinner. He put his wife and kids in a tent behind the cooling towers – that was their summer holiday! Life was just like *Auf Wiedersehen, Pet* – unbelievable!

There were some shady deals going on. Police used to check the site. Men were pulled in for selling cigarettes. Some lads bought new cars – eggshell-blue Zephyrs (Z cars) – with money from stealing the copper. Buster Jones had an ulcer on his leg so the nurse sent him home. He lost his leg with gangrene but still worked with a wooden leg. One day his leg fell off as he boarded the bus to Northwich. A lad had to chase after it for him. There were lots of strikes they were often called just so the men could go drinking. Flying pickets would police the strike.

Photographer Billy Hyland recorded life in Widnes for many years:

My father worked at ICI but he was a keen amateur photographer and I always wanted to do it as a profession. My brother Peter and I set up a studio above Whitaker's shoe shop in Albert Road. I worked all over the North West. I did a lot of work for Golden Wonder, who were the main employers in the area, for over twenty years, taking photos for the company magazine and trade journals. I also worked for Albright & Wilson, Fisons, ICI, and Glaxo, Evans Medical. I also worked for many breweries; Bass in Runcorn, Burtonwood Brewery in Warrington and John Smith's in Tadcaster. Many of the companies sponsored sport.

I worked with The Wids Rugby Union, Widnes Rugby League, greyhound racing, horse racing and golf tournaments. In 1969 I photographed a Kenny Ball evening at The Wids. They hosted really popular events and functions. Harry Greenwood invited me to the 1975 trip to Wembley playing Warrington – what a great week!

Widnes got to Wembley on seven occasions in ten years and I really enjoyed the trips, even when they lost. I photographed many weddings and portraits. I am now semi-retired but miss the weddings and the people. I often photographed the bride's wedding and then years later, their children's wedding. I often say, 'I know every church in the North West.' I never had a disaster with the photos but I always said if things went wrong I had a ticket ready to leave for Canada.

George Grace recalls his time at Widnes Foundry:

I started work in January 1955. It was a Scottish company so I was not paid for the bank holiday. Not a good start. My uncle worked there as a template maker and got me the job, as an apprentice boilermaker. It was a very good grounding. Everyone had to join the union and the dues were paid on a Friday night at the parochial hall across from The Grapes. Here the workers gathered for a good night out. Although they did the same job the apprentices were on a much lower wage, so the tradesmen always bought the drinks. I worked on a profiling machine making flanges. I went to night school in St Helens at The Gamble Institute for five years and earned a City & Guilds certificate in sheet metal work. The belief was if you could work in thin metal you could do it in thick.

There were a lot of women in the workforce, they red-leaded the steelwork. As I was a young man they seemed very old to me. They also made tea. It was wonderful place to work

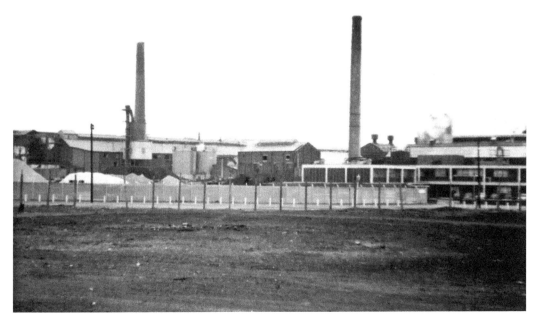

The Vine Works.

Widnes Stadium.

in the early days. I loved it so much that when I first started I would not take my overalls off. I was so happy working at 'our place', as it was known by everybody, that I would have gone for free. All the workers were very proud of the foundry.

Sport was popular and each year the town organised a rugby league works competition. All the companies took part – the foundry, McKechnie's, etc. It was a very rough game as many of the ex-professionals played a dirty game.

I slowly became disillusioned at the foundry. One day in 1961 the Managing Director walked down the yard and pointed at men and said, 'You, you and you – finish on Friday,' sacking men at will. I was not happy with that; I thought it was a terrible way to treat workers. So I went looking for another job. My friend Alan worked at The Vine (Ores Zinc Whites) and I asked him if they needed anyone. He said they needed a sheet metal worker. I went to the interview on the corner of Brook Street. The foreman said, 'You can start on Monday.' When I told the Managing Director at the foundry, he was not happy. He said, 'You can't,' but I moved on to The Vine the very next week.

Brian Chamberlain remembers teaching at Fisher Moore School:

I became a teacher in 1973 working in schools in Warrington but left to travel the world, but did not get far. I started work at Fisher Moore in 1975, which is now sadly demolished. I was a language teacher, teaching French and German, and I progressed to become Head of French and Head of Year. It was a well-known school and considered a difficult school, but

there was fun working with the teenagers. On Red Nose Day I was marking the register when I looked up and every pupil had a red nose on and they were making funny faces.

I thoroughly enjoyed my years there and was reluctant to retire, and I still miss the teaching days, although I am told things have changed now.

Teachers did not last long at Fisher Moore. One got hit over the head with a chair; one became a lorry driver and one a bus driver.

Sanctions were different then and corporal punishment was used. Teachers were allowed to use the cane. I hated it and found it very difficult, but even then the pupils could find humour in the process. One day the Head of Year said we had to discipline Michael, who was constantly in trouble. Neither of us was keen to do it so we flipped a coin and I lost. A popular programme at the time was the American police series *Kojak*, who was always sucking lollipops. Michael held one hand out, put the other behind his back and he took his punishment; he then brought out a lollipop and said, 'Who loves you baby!' I could not stop laughing.

I was responsible for a school coach trip to Boulogne on the ferry. I was accompanied by Peter Quinn the Deputy Head. Suddenly over the loudspeaker we heard, 'Would Mr Chamberlain come to the captain's cabin.' The little horrors had been pinching butter pats from the canteen and they were greasing the stairs. Luckily no one was badly injured.

A favourite pupil, we called him 'sparrow', could be disruptive so once I put him in the stockroom with a copy of the *Beano* or *Dandy*. He went home and told his mother and she came to the school to complain. I was called up to the office. As I walked in and she threw a punch – I ducked and she hit the deputy head!

Known as a rough school, it was difficult to recruit teachers at Fisher Moore:

As I came to the interview I was dismayed to see rolls of barbed wire like a concentration camp and the windows were smashed. Apparently Widnes had lost that weekend and that's what happened. The Headmistress, a lovely woman, she offered me a cigarette and a polo mint and asked, 'Can you breath?' I replied yes. She said, 'You've got the job.'

Brian Gill recalls his memories of Cheshire Police in the 1980s and 1990s:

I joined the army straight from school and served for nine years. I then joined the fire department, in Jeddah Airport, as a fire officer for two years and then came home to become an ambulance man. I applied to Cheshire Police as they were better paid. I started in Northwich and soon requested a posting back to Widnes. It was great to be a uniformed officer and to attend the rugby matches for free. I was voted the best tackler, having tackled a Leeds supporter who ran onto the pitch. I was promoted to CID. I was the lead detective on the Warrington bombing in 1993; a very sad job dealing with the victims. It was good to work in your home town but sometimes you who had to arrest friends and schoolmates; breaking up fights and then realising it was team-mate in the rugby team. But I always received respect from local people in the town. I joined the Regional Crime Squad in the North West and then moved to the Serious Crime Agency in the United Kingdom and Europe.

I am now working at the local housing trust dealing with antisocial behaviour – meeting villains who are now granddads. It is nice to see generations of families. In the early days I was very keen. I was asked to rush up to a street in Ditton. There was no reply so we kicked the

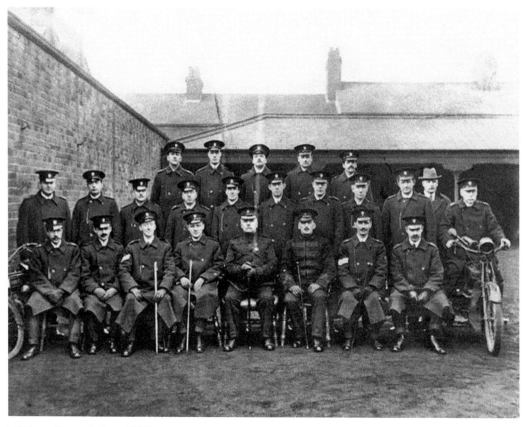

Widnes Constabulary, 1920.

door in. But it was the wrong house. The householder took it surprisingly well when he heard we had kicked down his front door. Next day I had to issue a warrant in Lacey Street; I rushed in and confronted a very shocked lady in her nightgown. Wrong property again! I had made two major mistakes in two days!

THE SILVER JUBILEE BRIDGE

After the war it was realised that the Transporter was not adequate. It was widely accepted that a fixed road crossing was required. Architects faced the problem of shipping on the Mersey and Manchester Ship Canal. There was also the problem of the shifting navigable channels. The architects, Mott, Hay and Anderson, decided a high-level scheme was the best solution. It was a great engineering triumph but for the residents of Widnes and Runcorn homes would be demolished and the town would be altered forever. The total cost was around £2.9 million. Approximately 220 men worked on the bridge, including fifty-five steel erectors, thirty riveters and ten scaffolders. Many of the workers were local men. Those who had to work at a great height (spider-men) averaged £28 a week, with labourers earning less. Work commenced in April 1956, when housing was demolished in West Bank. Work on the foundations was difficult and the workers had to work in up to 3 feet of

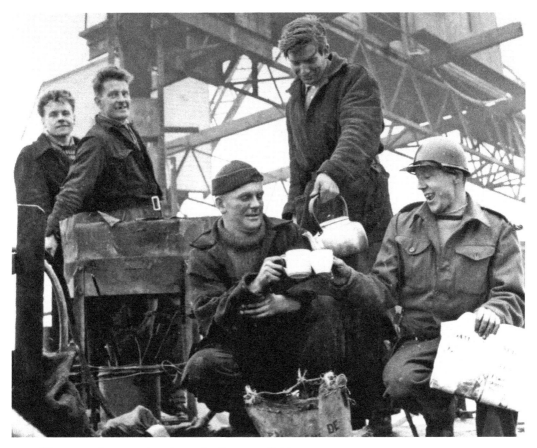

Riveters enjoy a tea break on the Runcorn Bridge.

water. It was also dangerous. In 1957 James Finnigan nearly drowned when he was knocked into the water by a swinging beam. He was saved by John Fahy and Gordon Sharrock.

It was not all plain sailing. There were strikes, the spidermen claiming unsafe working practices. It was hoped to open in January but it was officially opened by Princess Alexandra in July 1961. There was rivalry between men on each side of the bridge as each wanted to be the first to the top. The honour of being the first person to cross the bridge went to 29-year-old Terry Burns. Terry recalls:

I started on the bridge in 1957. The work lasted eighteen months; the subcontractors were Leonard Fairclough's. Dorman Long did the steel work. I was the first man to cross from Widnes to Runcorn at 290 feet and the gap was about 2 feet 6 inches. I jumped across and landed on the Runcorn side. The chief engineer was Mr McManus, from Australia. I climbed down and he presented me with a bottle of Guinness. We worked without a safety harness and the safety nets were no use. You could not work with the harness as you could not move about.

I had experienced steel erecting all over United Kingdom, working on high chimneys and cable masts, etc. I became famous for being on top. I was headlines in the *Daily Express* and the *Daily Dispatch* and there was a full front page in the *Weekly News*. There were no fatalities on the bridge but sadly one man was killed when he was laying pipes.

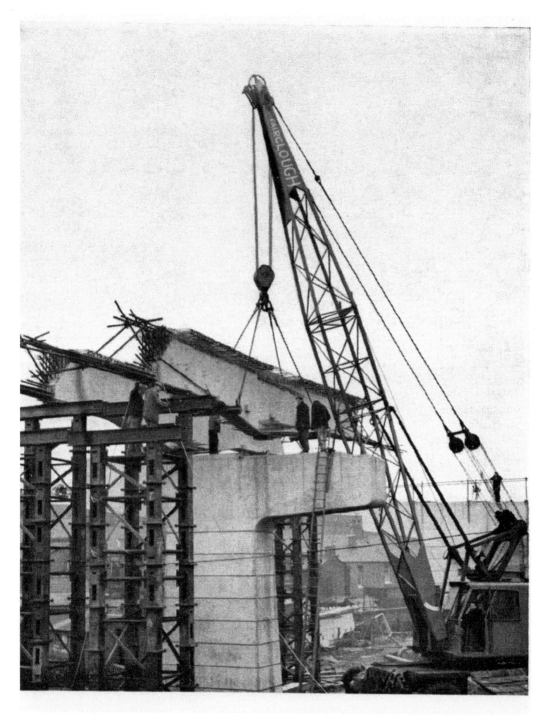

Above: Crane used to position deck beams on the road bridge.

Opposite: Workers on the Runcorn Bridge.

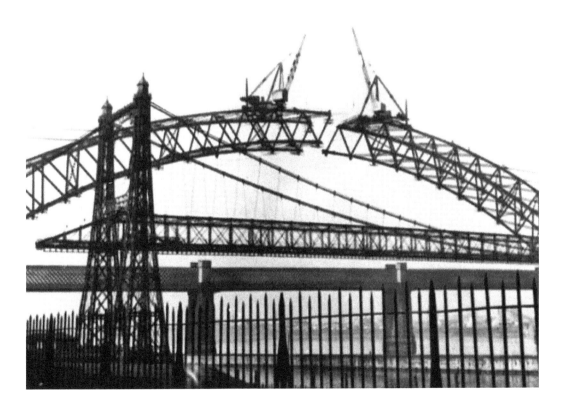

Runcorn—Widnes High Level Road Bridge

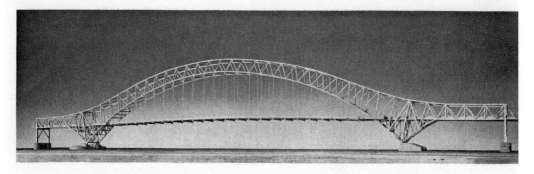

The bridge, built at a cost of £3,000,000, is of a similar design to the Sydney Harbour Bridge. Of arched type construction, it has a main span of 1,082 feet and a total length of 1,632 feet. The top of the arch is 306 feet above water level, and the bridge provides a 35 feet carriageway and a 6 feet footpath approached by new roads in viaduct to connect with existing main roads in Widnes and Runcorn.

Runcorn Bridge.

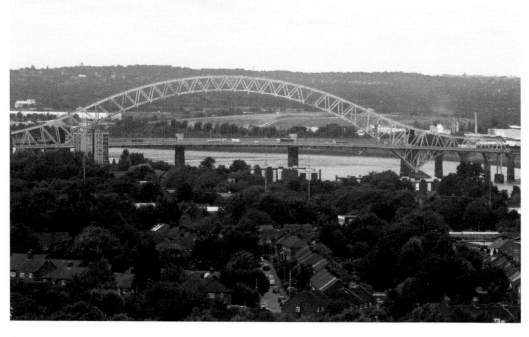

LOCAL GOVERNMENT REORGANISATION

In 1974 Local Government was reorganised. Widnes Borough Council was abolished and Widnes found itself outside its traditional county of Lancashire. This was a matter of regret for many people. It was a controversial decision to remove the natural boundary of the River Mersey and put Widnes in Halton Borough and part of Cheshire County Council. The closure of many of the heavy industries and dealing with the poisoned waste and abandoned factories had to be faced and a major land reclamation programme was begun.

The year 1989 saw the opening of The Catalyst, a unique museum dedicated to the chemical industry. The iconic tower building was built by John Hutchinson but became the headquarters of Gossage's Soap Works. How very different from 1920.

In 1998 Halton was granted unitary status. This was welcomed, as at last Halton would be in-charge of its own destiny. This gave them powers and functions to take control of strategic services in the borough and make decisions for the benefit of the whole community.

At the time of writing, recent austerity has sadly resulted in the withdrawing of funding by central government, making for hard choices in local government. Nevertheless, there are exciting changes happening in Halton. Widnes does not stand still and the new century has brought exciting plans for the town.

Construction of the Muni building.

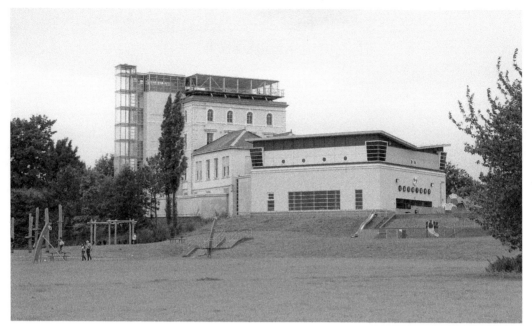

The Catalyst Museum.

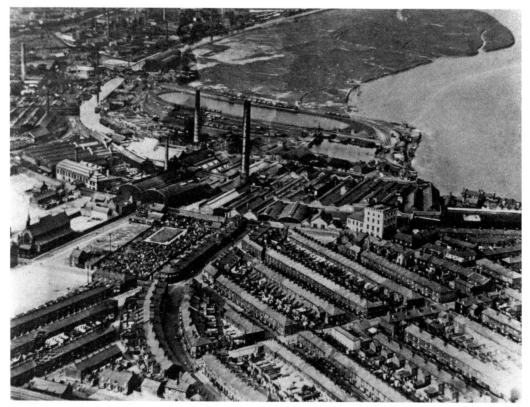

Gossage's Dock in 1920.

WIDNES: TODAY AND THE FUTURE

MERSEY MULTIMODAL GATEWAY

The Mersey Multimodal Gateway project (3MG), a partnership of Halton Borough Council, Eddie Stobart and the Stobart Group, is transforming the old West Bank Dock and will ensure the future of the town as a major transport hub. The first stage opened in 2006 and will eventually provide 5,000 direct jobs. In 2013 Tesco and Stobart's agreed to open a new distribution centre, bringing 750 new jobs to Widnes.

3MG now links Widnes with the road network and has daily rail links to the deep sea ports of Felixstowe and Southampton. It is a unique piece of infrastructure with unrivalled features.

Stobart's.

Above: 3MG Stobart's.

Below: West Bank Dock Tesco.

The rail access from the West Coast Main Line connects with high bay warehousing and an operational intermodal terminal facility – already handling in excess of 190,000 containers per year. It will provide environmental benefit nationally as it will take hundreds of heavy goods vehicles off our roads and motorways.

Further green policies will be provided by the new biomass plant at 3M – the largest waste wood renewable energy plant in the region. The plant will provide enough renewable electricity to power more than 35,000 homes each year.

ALSTOM

Alstom's new rail technology centre in Widnes is expected to bring hundreds of jobs to the town. Construction on the £21 million Alstom facility in Halebank, the United Kingdom's largest and most sophisticated site for train modernisation, began in 2016. Alstom will soon start to work on a €28m contract to repaint the fifty-six-strong fleet of Class 390 'tilting' Pendolino trains, which are used by Virgin on the West Coast Main Line. The site has more than 13,000 square metres of space and will be the largest rolling stock modernisation facility in the United Kingdom. This new centre for manufacturing will grow local skills and create hundreds of jobs both in Widnes and across the entire UK rail supply chain. Over 130 jobs will be created by summer 2017 when the technology centre opens with the potential for many more.

The Alstom Transport Training Academy will open in September 2017. The academy will support sixty-five apprenticeship places in its first year, and will deliver 15,000 training days a year when open fully.

Above and overleaf: Alstom.

THE NEW MERSEY GATEWAY BRIDGE

The Silver Jubilee Bridge has served Runcorn and Widnes well. The bridge opened in 1961 and is now crossed by 26 million vehicles every year. As the only route to cross the Mersey from Runcorn to Widnes it is a notorious traffic bottleneck, seriously affecting commerce in the region.

A second road crossing over the Mersey has been a long-held aspiration of Halton Borough Council and its neighbouring local authorities. In 2006 the Mersey Gateway Project, a major scheme to build a new six-lane toll bridge over the River Mersey between the towns of Runcorn and Widnes, was at last agreed. The new bridge will relieve the congested and ageing Silver Jubilee Bridge.

The project has strived to involve and communicate with the residents and Mersey Gateway volunteers are helping to tell the story of Halton's iconic new bridge. Volunteers work alongside Merseylink's team to staff the Mersey Gateway visitor centre and support a programme of talks, presentations and temporary exhibitions in local community venues, schools and colleges.

Work started on the Mersey Gateway Project on 7 May 2014 and it was inevitable that this major project would result in disruption for the local residents with road closures and diversions. Indeed, residents themselves often get lost in the road works! The road has provided an estimated 4,640 new jobs through direct employment, regeneration activity and inward investment. It will have three lanes across the Mersey in each direction and form the centrepiece of a new and improved high-standard link road connecting the national motorway network in North Cheshire with Merseyside. It was announced in July that within a few days, workers will be able to walk across the new route from Runcorn to Widnes for the first time. The bridge

Above and below: The Mersey Gateway.

Construction of the new Mersey Gateway.

will charge tolls; which is causing some resentment as even residents will have to pay a £10 annual registration fee.

Prior to the Industrial Revolution Widnes was a pleasant place for day trippers from Liverpool to enjoy the river. The arrival of the chemical factories would change the landscape forever. It was a mixed blessing. It brought wealth to the few and employment to the many. However, it also brought hardship, disease, pollution and land contamination. The workers came from all over Europe and this is reflected in the spirit of Widnes today. The town still maintains a wonderful community spirit and there is great pride in the town.

BIBLIOGRAPHY

BOOKS AND MAGAZINES

Hardie, D. W. F., A *History of the Chemical Industry in Widnes* (ICI, 1950)
Morris, Jean M., *Into the Crucible* (Arima, 2008)
Morris, Jean M., *Where Spring Never Came: Widnes 1919–1945* (Arima, 2007)
Whimperley, Arthur, *Widnes through the Ages* (Halton Borough Council, 1981)

ICI Magazine

Also available from Amberley Publishing

JEAN & JOHN BRADBURN

WIDNES

THROUGH TIME

The No. 1 Best Selling Colour

OVER 250,000 COPIES SOLD

Local History Series

This fascinating selection of photographs traces some of the many ways in which Widnes has changed and developed over the last century.

978 1 4456 0999 7

Available to order direct 01453 847 800

www.amberley-books.com